Kentucky Renaissance

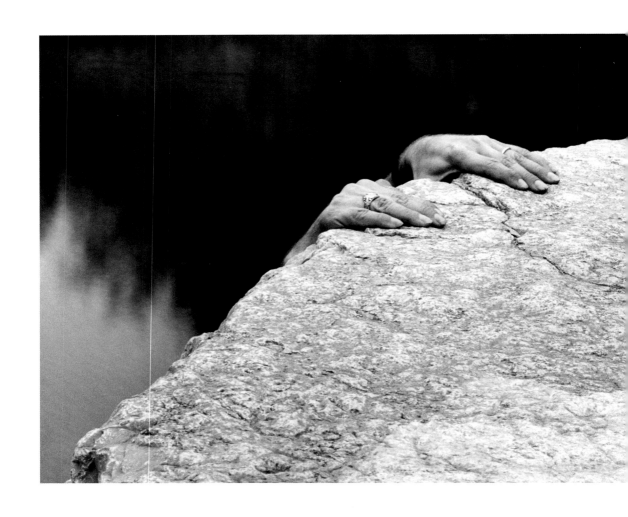

Kentucky Renaissance

The Lexington Camera Club and Its Community, 1954–1974

Brian Sholis

With an essay by John Jeremiah Sullivan

Yale University Press, New Haven and London
in association with the Cincinnati Art Museum

Published with assistance from FotoFocus.

Published on the occasion of the exhibition *Kentucky Renaissance: The Lexington Camera Club and Its Community, 1954–1974*, organized by the Cincinnati Art Museum.

Cincinnati Art Museum
October 8, 2016–January 1, 2017

yalebooks.com/art

Designed by Rita Jules, Miko McGinty Inc.
Set in Akkurat type by Tina Henderson
Printed in Italy by VeronaLibri

Library of Congress Control Number: 2016934972
ISBN 978-0-300-21898-5

A catalogue record for this book is available from the British Library.

The paper in this book meets the requirements of ANSI/NISO z39.48-1992 (Permanence of Paper).

10 9 8 7 6 5 4 3 2 1

COVER: Robert C. May, *Untitled [Fence, lanterns, and figures]*, 1968. Gelatin silver print, 6$\frac{1}{16}$ x 6 in. (15.4 x 15.3 cm). The Art Museum at the University of Kentucky, Lexington.
FRONTISPIECE: Cranston Ritchie, *Untitled [Hands on rock]*, ca. 1956–61. Gelatin silver print, 7 x 9 in. (17.8 x 22.9 cm). University of Louisville Libraries Special Collections.
PAGE VI: James Baker Hall, *Untitled*, ca. 1973 (detail of plate 40).
PAGE XVI: James Baker Hall, *Gene Meatyard*, ca. 1967 (detail of plate 22).
PAGE 34: Robert C. May, *Chris Meatyard*, 1973 (detail of plate 11).
PAGE 70: Van Deren Coke, *Beginning of Northern Belt Line—Fall*, undated (detail of plate 67).
PAGE 136: James Baker Hall, *Chairs*, ca. 1973 (detail of plate 89).

Contents

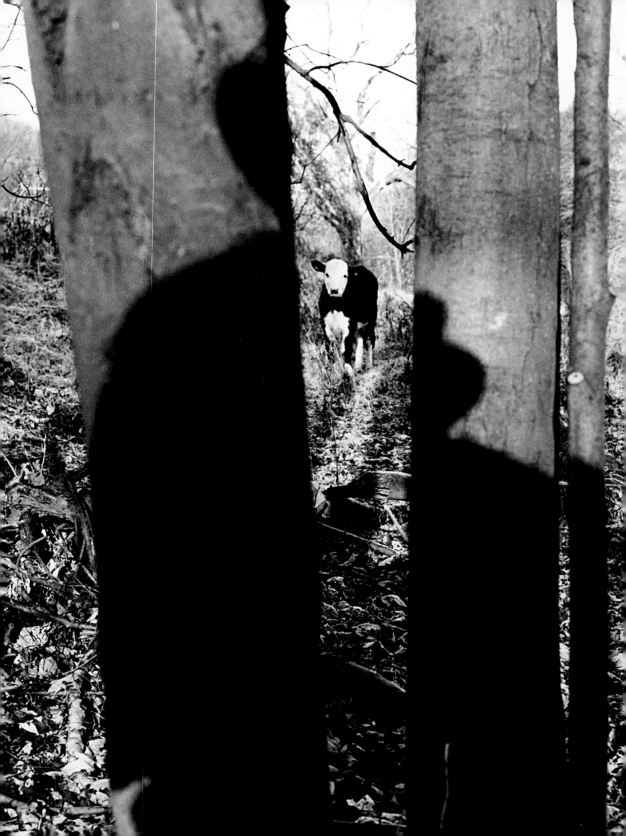

Director's Foreword

Kentucky Renaissance: The Lexington Camera Club and Its Community, 1954–1974 represents evidence to a point. When we teach and discuss the history of art, we are often too reductive in our approach. The decades from 1954 to 1974 are placed on a continuum, from Abstract Expressionism to Pop Art and onward. History as it happens, however, is far more complex and unruly than history as it is chronicled by later observers. I hope that this catalogue and its accompanying exhibition help bring to light a group of iconoclastic artists whose work challenges the rational progressions we so often seek.

The intertwined threads of history that more accurately represent the pluralism of art clearly ran through Lexington, Kentucky, at midcentury. Largely underappreciated, these artists are now joyously brought to light by curator Brian Sholis and the Cincinnati Art Museum team. Sholis's scholarship illuminates a fascinating story of artistic commune in our region and expands the canon of American photography.

At the Cincinnati Art Museum, we have long been interested in the study of photography. The first photography exhibition at the museum was mounted over one hundred years ago, and we have actively collected photographs for nearly fifty years. Our curatorial endeavors in photography are followed enthusiastically and supported by many, most notably the Schiff Family Foundation.

I am grateful to all who have launched and sustained this project with us. FotoFocus, the Andy Warhol Foundation for the Visual Arts, the National Endowment for the Arts, and our many public and private lenders all stepped forward to pursue this inquiry together. Thank you to each for your confidence and for your support of the Cincinnati Art Museum's mission in photography.

I look forward to a broadening appreciation for the artists who have called our region home, from Lexington to Louisville, from Cincinnati to Oxford. Their energies and creativity are significant and deserve a place in our art historical learnings.

Cameron Kitchin
Louis and Louise Dieterle Nippert Director
Cincinnati Art Museum

Her Majesty and the Monks

About fifteen years ago, at his house on Bell Court in Lexington, Kentucky, I heard the late great American writer Guy Davenport (MacArthur genius, National Book Award winner, celebrated painter, more) describe two hypothetical short stories, pieces he had not written (and never did write) but was playing with, or aware of as possibilities, as something that could be taken up if one were temporarily out of ideas. The first had to do with Ludwig Wittgenstein and Adolf Hitler and the strange coincidence that as boys they were briefly schoolmates. There is even a class picture that includes both of their child faces. Guy's life partner, Bonnie Jean Cox, was in favor of this story and wanted him to write it—nobody else could do it!—but Guy was hesitating, complaining that the setup suffered from a certain obviousness. Which was funny, but one knew what he meant. Reality had outdone whatever the writer could bring to the stage, had written a dark short story about two little boys who grew up to change the human race in ways both wonderful and terrible.

The second idea, the one that seemed to appeal to him more, had to do with a certain evening in the mid-1970s, when the respective armored-limousine caravans of Queen Elizabeth and the Dalai Lama had passed each other on a small road in central Kentucky. This had actually happened once, or almost, in Bourbon Country. The Queen was keeping her horses nearby—a handful of them, as she does to this day—and the Dalai Lama had just been paying respects to the ghost of his old friend Thomas Merton at the Abbey of Gethsemani, where Merton lived and is buried. In the story, this visit of his to meditate at the grave of "Father Louie" had overlapped with one of Her Majesty's to her stables. The passing took place in a remote part of the state; there aren't many big roads. They passed each other.

In Guy's version, of course, it went much further. In Guy's story the passing of the caravans happened during a violent thunderstorm. The road was completely subsumed, the vehicles got swamped, lightning flashed, and both entourages had to make for the only structure in sight, a barn on a high hill, a Kentucky barn in maybe the most beautiful part of the state, in the Catholic country not far from Abraham Lincoln's birthplace. The night was black. The power had gone out.

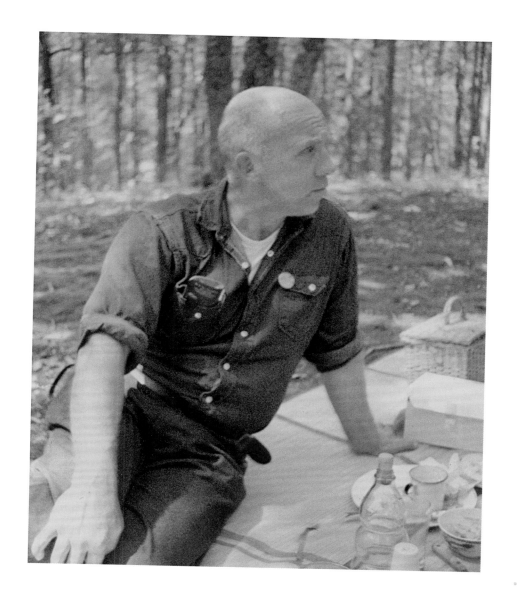

Fig. 1 Carolyn Hammer, *Untitled [Thomas Merton]*, undated. Chromogenic color print, 3 x 2½ in. (7.6 x 6.3 cm). University of Kentucky Libraries Special Collections Research Center, Lexington.

Merton's spirit was summoned from the monastery. Her Majesty seemed unfazed by this display of supernatural power. He came in a truck. Or else he had been riding in the limo with the Dalai Lama. They were returning from a visit to a waterfall or a restaurant. I can't remember how Guy managed to get him there, but it makes no difference, he would have come. So it was Thomas Merton, the Dalai Lama, and Queen Elizabeth in the barn. Guy seemed to delight in the notion that, for a brief time, this gathering could easily have occurred, two-thirds of it. The circumstances were in place. And if it could have happened, it was interesting to ask, how *would* it happen? The dozen or so bodyguards and attachés do what they can to make everyone comfortable. Not much is needed. They start a fire, prepare tea, arrange a little Athenian scenario for the principals to sit in and speak. The thunder booms outside.

Her Majesty gives memories of the war. Certain people had wanted to send her and her sister to America, but to this her mother gave a famous reply: "The children won't go without me. I won't leave the King. And the King will never leave." At that moment Tenzin Gyatso was being announced as the new Dalai Lama, seated on a golden throne, enshrouded in silk robes, a golden cap on his head, in the city of Lhasa. Elizabeth mentions music. Merton has only his weird little prayer drum. The Dalai Lama sings a bewitching song he remembers from childhood, a song of the high Tibetan plateau. Merton and the Queen flirt ever so slightly. He is English, after all, or sort of. Also sort of French. And misses the company of women. His voice is Kentuckian. (Once I listened to him speaking on a tape from the 1960s and was startled, given the exoticism of his background, to find the accent so familiar.)

A small disagreement arises and is in the end resolved not by either of the spiritual leaders, but by the Queen. Manners reign. That's what Davenport would have wanted to do. He would have shown how their customs and different traditions, monarchical, monastic, Eastern and Western, man and woman, could under the right pressures reach back and find the necessary code for making peace. Guy liked to write about what was radical in human nature, radical not in the political sense but in the deeper etymological one ("Of, belonging to, or from a root or roots . . . inherent in the nature or essence of a person or thing").

I don't remember as much as I should about where he took the idea. He may not have divulged many details. He was toying with it and us. I could have invented half of these. A nonexistent imaginary story is a hard memory to keep stable.

For many people over fifty years Davenport was himself a figure in a semi-miraculous fable: he and his friends were characters in a barn on a hill. The South may always be to some degree a Sahara of the Bozart, as Mencken joked, but for that very reason, perhaps, we imbue our artists with a unique luminosity. We need them. And when a community does manage to form, however loosely, there's a glow. You're huddling together inside something, inside a culture, but against something, too.

It usually seems that there isn't so much a Kentucky school of writers and artists as there are clusters of irredeemable individualists. There's Wendell Berry up in the lonely northern counties, singing beautifully (if too late) the virtues of the preindustrial age. We had Guy in Lexington, corresponding with Buckminster Fuller, and now it feels as if Erik Reece has taken Guy's place there somehow, spiritually. The poet Nikky Finney lived in Guy's old house for twenty years, and was living there when she won the National Book Award in 2011. Other names: Hunter Thompson (Louisville), Robert Penn Warren (Guthrie, in the west), James Baker Hall (Lexington). There's Ed McClanahan, like Berry from the northern part of the state but as different as could be from his colleague—seemingly so, some would say. Chris Offutt is also from northern Kentucky. Bobbie Ann Mason, the novelist, comes from the very very westernmost tip of the state. Elizabeth Madox Roberts and James Lane Allen—those were the names my grandparents used to mention. Most recently have arrived ZZ Packer, C. E. Morgan, and John Daniels. Crystal Wilkinson and Fenton Johnson. Not one of these writers seems to have an enormous amount to do with any of the others. Yet somehow they're all identifiably Kentuckian.

I grew up hearing about the Lexington Camera Club from my uncle John, a lifelong amateur Lexington photographer, but I didn't pay attention, or become aware of the vague central Kentucky Enlightenment to which the club belonged, until Guy introduced me to the work of Ralph Eugene Meatyard. Meatyard had collaborated with Guy as well as with Wendell Berry. They visited Merton out at the monastery. They all knew each other. Guy was always attracted to, in his words, "the dawn of things, before

betrayals and downstream mud," and Meatyard was an artist who, self-taught and working in a relatively cut-off place, had reached all the way back and down, brought forward again one of the oldest symbols and tools, the mask, and made it new again. At Woolworth's he found Halloween masks that almost looked as if something had gone wrong during the production process, bringing to mind the faces in Picasso's most grotesque paintings—or Snuffy Smith's wife, if you met her while you were having a bad acid trip. Meatyard's subjects wore these masks, posing in otherwise natural circumstances. The effect is indescribable, but definitely unsettling.

Only since Guy died have I come to know the work of Van Deren Coke. The pictures he made late in his career exist in the space between photographs and paintings, in a technical threshold that suggests other worlds. For me they are revelations, recovering in their strangeness what I imagine might have been the sensations of the patrons at the first Surrealist exhibitions. Coke's maternal grandfather ran the biggest hardware store on Main Street, during the years when my maternal great-grandfather ran the biggest shoe shop, Baynham's, about a thousand feet away. They must have passed each other constantly. Coke walked away from the family hardware business to pursue his art. Now I am fascinated to know more. I hope and trust that some of the photographers included here will have the same effect on you. Long live the Lexington Camera Club!

—John Jeremiah Sullivan

Acknowledgments

The Lexington Camera Club's members were remarkable artists, and I have delighted in learning more about their achievements and those of their friends and peers. This exhibition and catalogue are a selective history that focuses on those, active after midcentury, whose passions took them in directions most readily identifiable today as art photography. Many club members go unmentioned in these pages, but every participant's efforts contributed to what made the Lexington Camera Club unique in its time and important for us to study today. The ground for that study has been ably prepared by previous students of the group, and my own efforts were aided by the talent and dedication of many people within and beyond the Cincinnati Art Museum. First thanks go to John Jeremiah Sullivan, whose life in Kentucky arts and letters counterbalances this Chicago native's outside perspective.

 Within the Art Museum walls, I am grateful to director Cameron Kitchin, who approved this exhibition soon after his arrival and has since been its vocal advocate. I would also like to acknowledge the contributions of Cynthia Amnéus, chief curator; Susan Hudson, director of exhibitions and collections, and Jay Pattison, chief registrar, who ably coordinated the exhibition; Kirby Neumann, director of development, and Raymond Pettit, grants and foundations manager; Emily Holtrop, director of learning and interpretation, and her team; Kim Flora, head of design and installation, and the several crews under her leadership, especially Chrystal Roggenkamp, senior designer; Rob Deslongchamps, head of photo services; and Galina Lewandowicz and her team of librarians. I am particularly indebted to Emily Bauman, curatorial research assistant, for her thoroughness, insights, and flexibility as this project evolved, and to Linda Pieper, for administrative assistance.

 I am grateful to Patricia Fidler, our publication partner at Yale University Press, for seeing value in this project and encouraging us at every turn. Her colleagues Tamara Schechter, Kate Zanzucchi, Mary Mayer, and Kristy Cottrell offered the perfect mix of courtesy and stringency. I also thank freelance copyeditor Miranda Ottewell and proofreader June Cuffner. Book designer Rita Jules at Miko McGinty Inc. conveyed the club's vibrancy and the freshness of its members' art through her treatment.

I am grateful for the generosity of the public and private lenders who provided works for the exhibition, offered other in-kind support, and did not tire of my numerous questions during its preparation. These include Stuart Horodner, Janie Welker, and Bebe Lovejoy at the Art Museum at the University of Kentucky; Frish Brandt, Ola Dlugosz, and Rebecca Herman at Fraenkel Gallery; Gail Kennedy and Deirdre Scaggs at the University of Kentucky Special Collections; Elizabeth Reilly, Marcy Werner, and Amy Purcell at the University of Louisville Photographic Archives; Guy Mendes; Sarah Wylie Van Meter and Mary Ann Taylor-Hall; Dr. Paul Pearson and Mark Meade at the Thomas Merton Center at Bellarmine University; Charles Traub; Thomas Meyer; David Eisenman; and multiple anonymous lenders.

A list of lenders, however, omits the many others who bestowed favors upon me while preparing this exhibition. The first word in the first e-mail I received in response to an exhibition-related query was "absolutely"; the warmth and helpfulness it suggests characterized my good fortune in this undertaking. For their kindness, generosity, professionalism, and/or knowledge of the subjects this exhibition addresses, I am indebted to Jin Auh and Jessica Calagione at the Wylie Agency; Carissa Barnard; Zach Baron; Esther Bell; Wendell Berry; James Birchfield; Joshua Chuang; Lynda Corey Claassen at the Mandeville Special Collections Library, University of California, San Diego; Joan Coke; Sarah Dorpinghaus and Judy Sackett at the University of Kentucky Libraries; Michael Famighetti and Sarah Dansberger at Aperture Foundation; Rob Giampietro; David Gierlach; Mary Ellen Goeke; Jonathan Greene, who graciously allowed me use of his title when I unwittingly stumbled upon it, and Dobree Adams; Sophie Hackett at the Art Gallery of Ontario; Stefanie Hilles at the Akron Art Museum; Sarah Klayer; Phillip March Jones; Matthew Mason and Anne Marie Menta at the Beinecke Rare Book and Manuscript Library, Yale University; James Maynard at the Poetry Collection, State University of New York at Buffalo; Jessica McDonald and Richard Workman at the Harry Ransom Center, University of Texas at Austin; Diane and Christopher Meatyard; Erin O'Toole at the San Francisco Museum of Modern Art; Matthew Porter; Erik Reece; Stephen Reily and Emily Bingham; Bill Renschler; Thomas R. Schiff; Jack Shoemaker; Elizabeth Siegel at the Art Institute of Chicago; Diana Stoll; Cindi Strauss; Barbara Tannenbaum; and Hannah Whitaker.

Earlier exhibitions and books provided a starting point from which to begin research, particularly Robert C. May's 1989 University of Kentucky Art Museum exhibition and catalogue on the Lexington Camera Club and Barbara Tannenbaum's unparalleled 1991 Akron Art Museum exhibition and catalogue *Ralph Eugene Meatyard: An American Visionary*. I have built on their work and the efforts of many others, and hope that my endeavor increases awareness of a remarkable group of artists and broadens readings of modern American photography.

On a personal note, my parents, Vic and Kay Sholis, likely never expected to see themselves acknowledged in an art museum catalogue. Their decades of open-mindedness and unconditional support allowed me to get to the point where I could thank them in print.

Lastly, many authors acknowledge their partners by saying a book "would not exist" without them. In my case it is true. Three months before the manuscript was due, Julia Dault and I were blessed by the birth of our son, Walker Sholis. As I completed the research and writing of this catalogue, she selflessly covered night-shift newborn care, gifting me dozens of uninterrupted hours to read and write. I hope Walker grows up with the love for the arts that we both share, and will be doubly blessed if he inherits Julia's empathy, generosity, and patience. This book is for them, with unceasing love.

Brian Sholis
Curator of Photography

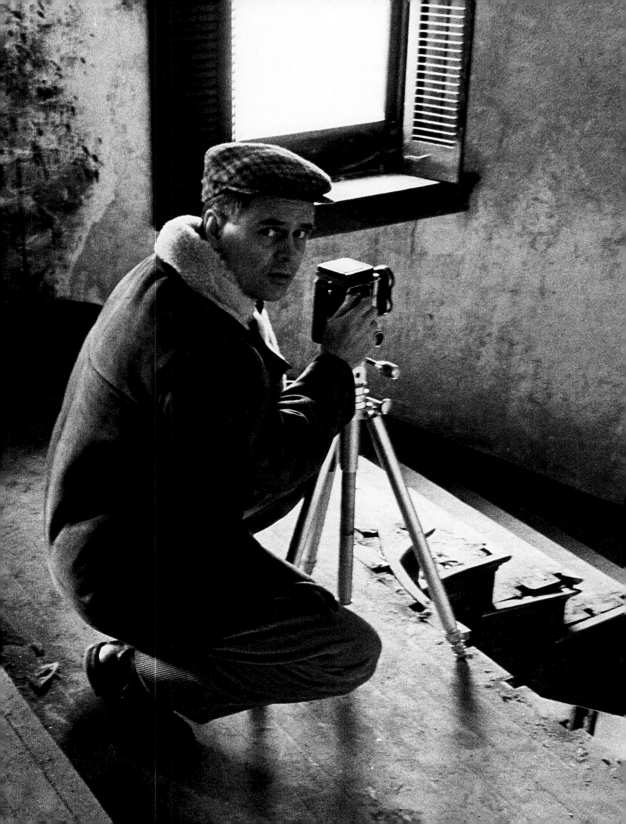

Assembly Required

Brian Sholis

On a Tuesday morning in January 1967, with the temperature right around freezing, three friends squeezed into a car in Lexington, Kentucky, and hit the road. The man who conceived the trip, poet and publisher Jonathan Williams, had repeatedly crossed America at the wheel, reading poems—and proselytizing for poetry—in colleges, high schools, YMCAs, gas stations, churches, and department stores. (He sold the Jargon Society books he published to help defray costs.) Tall and with a sonorous voice, Williams had a catalytic energy. His talent for friendship and his willingness to travel wove together a network of experimental writers and artists tucked in out-of-the-way corners of the country. His companions that morning, writer Guy Davenport and photographer Ralph Eugene Meatyard, had first met three years earlier, at Williams's suggestion. Davenport was gaining renown as a translator and had recently published his first books of poetry; Meatyard's photographs were admired and exhibited around the country. The previous year Williams had published Davenport's long poem *Flowers and Leaves*. Photographs by Meatyard adorn its front and back covers.[1]

The trio was headed seventy-five miles southwest, to the Abbey of Gethsemani, so Williams could introduce Meatyard to Thomas Merton, known also as Father Louis. They got lost several times along the way. Merton had lived at the abbey since 1941, and had risen to international prominence in the late 1940s with the publication, in quick succession,

of the autobiographical *The Seven Story Mountain* and the penetrating *Seeds of Contemplation*. Merton's plainspoken accounts of his life and spiritual journeys endeared him to millions of Catholics at a time of great change in the church, and his literary style prompted admiration from secular readers as well. Though he had been cloistered in a hermitage since 1965, Merton's fame brought many visitors to his door.

The car deposited its passengers at Gethsemani in late morning. Merton's quarters were "a nice comfortable little cabin out in the woods, out from the monastery," as Davenport later recalled. "It was heated by an oil stove, I think. Bathroom was still an outhouse."[2] The men sat down to "a four-hour winter conversation over Trappist cheese and bread with bourbon from one of the distilleries nearby."[3] Here, at a Cistercian monastery nestled into the stony hills of central Kentucky, was an unlikely confluence of figures: four men of disparate backgrounds, each a confident artist, each attuned to new developments in poetry, philosophy, and art. They had come to Kentucky for different reasons: Davenport to teach English at the university; Meatyard to work for an optician; Merton to retreat from the world and pursue his spiritual calling. Williams recognized remarkable figures and wanted to forge relationships among them, so he visited from North Carolina frequently. As Davenport later said, "Jonathan knows at least five people in every town in the United States. There is no such thing as being too small for Jonathan."[4]

Their conversation that day must have ranged widely; certainly poetry, a shared passion, was one subject, and another was Meatyard's photographs, which Merton immediately admired. (Merton had pursued photography with increasing avidity since the early 1960s.) Perhaps Meatyard and Merton also discussed Zen Buddhism, a subject they had arrived at from different places. Merton came to Buddhism in his attempt to better understand Christian mysticism; photographer Minor White had introduced Meatyard to the philosophy in 1956, recommending books on Zen (fig. 2).[5]

Whatever the subjects of their conversation, the introduction was a success. Writing in his journal the following day, Merton confided, "The one who made the greatest impression on me as artist was Gene Meatyard, the photographer."[6] Meatyard felt similarly: "We hit it off famously from the first. Our interests were all the same, some more avidly in one area, some another."[7] The two men began a correspondence and paid visits to each

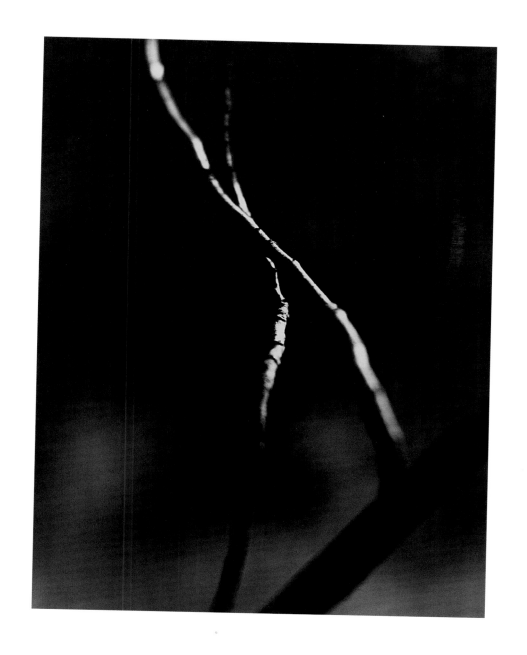

Fig. 2 Ralph Eugene Meatyard, *Untitled*, 1959. Gelatin silver print, 7 x 5⅜ in. (17.8 x 13.6 cm). Courtesy Fraenkel Gallery, San Francisco. This photograph is part of a series later identified as "Zen twigs."

other.[8] Writing to Merton in August, Meatyard suggested a novel endeavor: "Would you be willing to try something in an experimental vein? . . . What I propose is to see how closely I, or any artists [*sic*] can connect with the utterances of another. If you were to send me words, prose or poetry and number of words doesn't matter and I don't necessarily understand the personal or private meaning of them—then try to make a photograph . . . of them? We might also if that works try my abstracted photo first and then your words."[9] Three days later Merton responded: "I like very much your suggestion of trying something experimental; poems and pictures. Let's think about that."[10]

Meatyard's openness to experimentation of this sort was due in no small part to another encounter more than a decade earlier, one that would place him on the creative path he followed until his death in 1972. It likewise reshaped the artistic community in Lexington, helping to forge a group of photographers whose talents have been vastly underappreciated during the past forty years. Meatyard has been the subject of several museum retrospectives and numerous critical assessments, securing his place in the pantheon of leading American photographers. His soaring reputation, rightly deserved, has largely separated him from the immediate context in which his work developed. This has created at least two side effects that should be addressed. The peculiar, uncanny characteristics of his best-known photographs, combined with our unquenchable thirst for narratives of solitary artistic genius, have remade a cosmopolitan artist and dedicated mentor into a backwoods folk hero. And the varied and powerful work made by his peers and friends, which Meatyard himself acknowledged repeatedly as important to the story of photography, has gone largely uncelebrated beyond the region. Placing Meatyard's achievements back in their proper context redresses both unfortunate circumstances, and helps recover a truer understanding of the internal dynamics of this remarkable artistic community. These were not just friends; they had a club. It met monthly, and when Meatyard joined, the story took a fascinating turn.

———

During the summer of 1954, the *Lexington Herald-Leader* sponsored "snapshot" contests and reproduced winning entries in its Sunday pages.[11] Many of the triumphant photographs were emotionally simple and conventional in their design; imagine, if you will, two girls hand-in-hand as they jump into a crowded public swimming pool, or a small boy watering a garden of flowers with a hose. But a few entries expressed something richer, and those pictures were often by people affiliated with the Lexington Camera Club, such as Van Deren Coke and the young Robert C. May.

The club's first meeting was held in December 1936, when Louis Edward Nollau, an engineering professor at the University of Kentucky, spoke about the history of photography. Its members were professionals—doctors, lawyers, college faculty—but not professional photographers; pursuing their creative vision was an avocation, an activity for nights and weekends. Dues were five dollars yearly, or a dollar for students. The club's first formal exhibition was held in 1940, and later that decade the group could claim dozens of members.[12]

In 1954 Ralph Eugene Meatyard was entering photographic contests on his own, including those sponsored by the Illinois State Fair or the Photographic Society of America, an umbrella organization for amateur camera clubs.[13] Meatyard had purchased his first camera in 1950, after the birth of his son Michael, and in the subsequent few years had become adept at the medium.[14] These pursuits were encouraged by the fellow photography enthusiasts he met through his day job at the Tinder-Krauss-Tinder optical firm. The shop sold not only eyeglasses but also camera equipment, and Lexington Camera Club members would gather there on weekends to discuss their latest pictures, ogle new lenses, and stock up on film. Coke, who frequented Tinder-Krauss-Tinder, was one of the club's leaders, and at some point in 1954 he encouraged Meatyard to join its ranks. By November, when Coke organized *Focus on Lexington and Fayette County* for the Art Gallery of the University of Kentucky, an exhibition of select club members' work, he saw enough potential in Meatyard to include a dozen of his prints.[15]

Club meetings during this period were held on the first Thursday of the month in room 208 of the Fine Arts Building on the University of Kentucky campus. As many as two dozen men—throughout its history, the club's members were overwhelmingly male—would pack into the

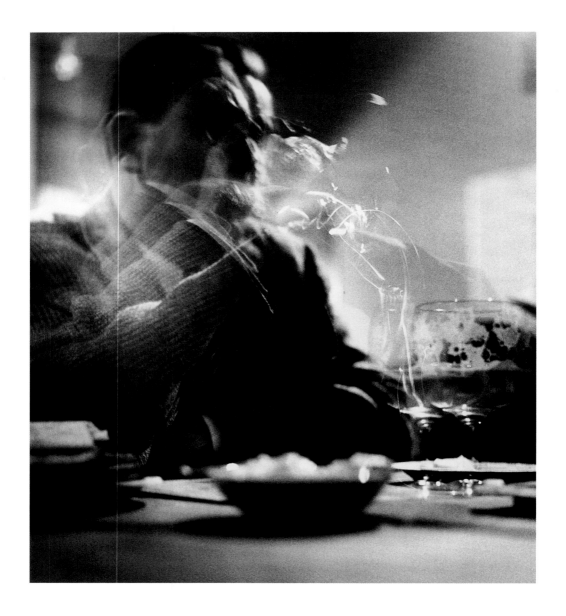

Fig. 3 Ralph Eugene Meatyard, *Untitled*, ca. 1957. Gelatin silver print, 11¾ x 10½ in. (29.8 x 26.7 cm). Courtesy Fraenkel Gallery, San Francisco. This photograph of Van Deren Coke was likely taken after a Lexington Camera Club meeting.

1,000-square-foot classroom to study and discuss up to fifty photographs. Members wishing to have their work critiqued would bring four or five prints. Those photographs would likely represent several different aesthetic directions or animating impulses, as the club never required its members to adhere to any guidelines or fulfill specific assignments. (This freedom distinguished the Lexington Camera Club from the many clubs affiliated with the Photographic Society of America.) "The club's meetings were somewhat formal," as May noted later. The prints would be placed against the chalkboard for attendees to examine before the meeting was called to order. After welcoming remarks, each member was given a slip of paper with spaces to record a score for each photograph. Those scores were totaled and averaged, and the prints with the three highest average scores were selected as that month's "winners." These prints were then discussed at length by the group.[16] Later in the evening, several participants would usually retire to a nearby bar for further socializing (fig. 3).

Coke, who came from a wealthy family, had begun his explorations of photography at a very early age. He endeavored to meet Edward Weston in California while still a teenager, for example, and by the early 1950s became a mentor to several of the club's most promising members. In 1955 Coke effectively created a club within the club by offering photography workshops in his home for four students: Meatyard, May, Jim Bill Craig, and Dr. Zygmunt S. Gierlach. He taught them Ansel Adams's Zone System, a technique for film exposure and development; showed them prints by Weston that he owned; and emphasized photography as a medium for creative expression. He believed that meaning arose not only from the subject of a photograph but also its composition, the balance of darkness and light, the focus, and the position from which the photograph was taken. As a handout Coke gave his students phrases it, "Art itself lies within the man—the piece of work reflects it. We must have a clear idea why we photograph if we wish to transmit our ideas to others. Our job in society is revelation."[17] "Van's classes gave us each a new and fresh approach to photography," May later wrote, one that "lasted through the remaining period of the club's existence. The active members would come and go throughout the years, but there was always that special and unique individual approach to photography that held the club together."[18]

One can intuit Coke's encouragement in Gierlach's explorations of both realistic and abstract photography. During the mid-1950s he created straight photographs, such as *Sunday Morning*, of a man reading the newspaper as seen through his apartment window—one cell of many in a modern apartment building's grid (plate 32). But as the lessons emphasizing personal expression took root, Gierlach propelled himself in a direction uniquely open to him. By day Gierlach was a radiologist, and he began using medical equipment to make photographs. He scanned an alarm clock "with an ordinary diagnostic X-ray machine," revealing sprockets and gears in a composition reminiscent of Man Ray's photograms (fig. 4).[19] His *Peafowl* rendered the bird's colorful wings a semi-abstract fretwork of veins (plate 97). And his use of a bell pepper offered a fresh vision of a photographic subject made famous a quarter century earlier by Edward Weston, Coke's inspiration and first mentor (plate 96). By the early 1960s the evolution of Gierlach's work led to completely abstract pictures (plates 93–94). To make these works, Gierlach employed filters normally used to take precision tests of X-ray equipment; by repeatedly exposing the image and moving these filters slightly out of register, Gierlach created stunning moiré patterns that reminded the artist of spiders' eyes. In their vision-straining complexity, these works dovetail with the Op Art movement emerging at that time. Gierlach, who identified himself as a "patron of art" and opened a small gallery at Doctor's Park in the mid-1960s, created photographs whose playful experimentation and rapid stylistic shifts were emblematic of the Club's most dedicated and talented amateurs.

Of the small circle of students he invited into his home, Coke became especially close to Meatyard. As Meatyard later remembered, "I was more or less taken under Van's wing as his first 'student.' For a number of years until he left Lexington, and still afterwards occasionally, we worked together, with one of us leading the other. I have found that teachers often grow by being led by their students."[20] What might seem like self-aggrandizement was in fact an accurate reflection of their mutually beneficial creative alliance. "To write objectively about an outstanding student is difficult but certainly pleasurable," Coke noted in a 1959 article. "He is part of you and you are part of him."[21]

The two photographers explored Lexington and its environs, cameras in hand. They sought places overrun with foliage or buildings shifting on

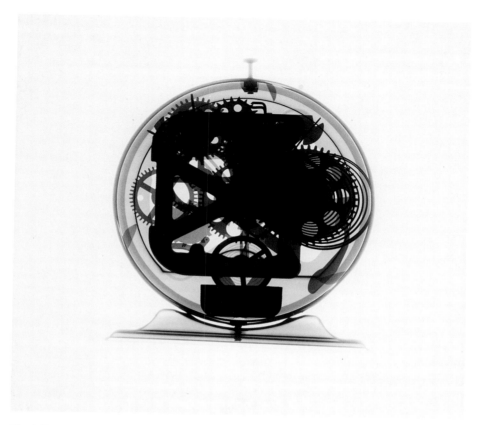

Fig. 4 Zygmunt S. Gierlach, *Untitled*, ca. 1955. Gelatin silver print, 6¾ x 7¼ in. (17.1 x 18.4 cm). University of Kentucky Libraries Special Collections Research Center, Lexington.

their foundations, evocative settings in which to arrange compositions. The photographer Henry Holmes Smith described Coke's photographs of the period as having a "cruel directness of feeling," and noted their "melancholy, anecdotal" qualities. One can certainly see this in his 1950 picture of smashed and overturned cars scattered on gentle hills, or in his 1955 image of an umbrella emerging from the gloomy doorway of a sepulcher in Lexington National Cemetery (plate 50). (In a related project, Meatyard assiduously photographed cemetery sculptures and head-stones.) Coke and Meatyard also collaborated directly on a humanistic portrayal of the African American community living along Georgetown Street in north Lexington (plates 37–38). Undertaken in 1955–56, these photographs would be exhibited in both Lexington and New York City,

where photographer Roy DeCarava mounted the prints in a group exhibition at A Photographer's Gallery.[22]

Coke's contacts in the world of photography benefited the Lexington Camera Club. In early 1956 he served as exhibition chairman for *Creative Photography 1956*, an invitational exhibition composed of ten prints each by seventeen photographers. Today the list of artists makes Coke seem clairvoyant: works by Ansel Adams, Ruth Bernhard, Wynn Bullock, Harry Callahan, Arnold Newman, Charles Sheeler, Edward Weston and his son Brett, and Minor White joined those of Coke and Meatyard on the walls. But, as the artist list also makes clear, Coke's vision of photography differs dramatically from the we-are-the-world sensibility of Edward Steichen's *The Family of Man*, presented at New York's Museum of Modern Art the previous year. Rather than seek the qualities that bind people together across cultures, the participants in *Creative Photography 1956* pursued highly individualistic, almost Romantic themes—the kind espoused in the pages of *Aperture*, which duly published a twenty-five-page portfolio devoted to the exhibition's artists.[23]

That summer, Coke and Meatyard traveled to Indiana University for a three-week photography workshop organized by Henry Holmes Smith. The highly structured event included extensive discussion about the interpretation and analysis of photographs, often using techniques borrowed from I. A. Richards, a literary theorist known for his "practical criticism."[24] The second week was given over to shooting new pictures in different settings, while the final week consisted of group critiques. The photographers Minor White and Aaron Siskind each visited for several days to lead sessions.[25] During this intensive seminar, Coke and Meatyard each increased their understanding of photography's relationship to the self, as well as of the medium's autonomous values. Their time in Indiana served as the culmination of several years of shared photographic activity and study. At the beginning of 1954 Meatyard had submitted his pictures to amateur talent contests; a little more than two years later, thanks in part to Coke's camaraderie, his photographs hung on gallery walls alongside those of many leading modern American photographers.

———

Over the next decade, Coke and Meatyard would advance into realms previously unexplored by Lexington Camera Club members. In fact, Meatyard's experiments pushed further, faster: by the end of the decade, several of the photographic series he pursued avidly would have confounded not only the public but also many fellow photographers. The student eclipsed the teacher. Meatyard also, of necessity, *became* the teacher: late in 1956 Coke left Lexington and enrolled in Henry Holmes Smith's program at Indiana University, where he would study both fine art and art history. This decision led to further study at Harvard, and then to a thriving career as a writer on photography, a teacher, and a respected curator. Though he would visit his hometown regularly and correspond with Meatyard and other club members, Van Deren Coke's time as a de facto leader of the group came to its end.

The late 1950s was a period of intense aesthetic and intellectual development for Meatyard. He read widely and photographed in nearly all his free time. By the time he delivered a lecture to the Louisville Photographic Society in 1959, he had identified no fewer than twelve distinct series of photographs on which he labored.[26] Among these were his "uncanny photographs" and "emotionalistic photographs," descriptions that suggest his general disavowal of photography's documentary capacity. As he wrote in a letter to Williams in March 1962, "I have been shooting several varieties of pictures and enjoying the romantic or surreal the most."[27] From this point forward Meatyard mostly constructed scenes for the camera and tested its limits and the specific ways it recorded visual information. He was not much of a darkroom manipulator, but he was open to any influence he could exert over the negative itself.

Though he is best known today for portraits of family and friends in which the subjects often wear ghoulish dime-store masks, during this period such photographs were only one strand of Meatyard's rich and increasingly varied output. Intrigued, for example, by the achievements of abstract painters and conversant in the dialogue about those artworks, Meatyard set about finding "new aspects of art belonging only to photography."[28] He created depictions of paint swirls frozen in ice; "no-focus" pictures; photographs of thin branches or leaves, which his son Christopher later identified as "Zen twigs"; and images of light on water, a series he would add to every year from 1957 until his death in 1972. Meatyard was a deliberate photographer, and among the lessons he brought back from

the Indiana University workshop was Minor White's endorsement of previsualization, by which a photographer calls to mind the finished composition before releasing the shutter. Despite their seemingly unpredictable subject matter—natural elements do not pose for the lens—Meatyard's pictures are marked by choice more than by chance.

The no-focus pictures, begun in 1958, exemplify this purposeful approach (plate 106). Reevaluating his earliest work, Meatyard became increasingly attracted to the backgrounds he had selected as appropriate settings for other subjects, and which were out of focus. (Coke had encouraged him to find a scene and then place a subject in it.) But no-focus was not to be the same as out-of-focus; simply changing his lens settings would not suffice. To make works that truly approached the realm of pure abstraction, Meatyard spent months looking through an unfocused camera before exposing his first roll of no-focus photographs. The resulting images suggest a larger world, but their connection to reality is tenuous, their forms seemingly porous, without boundaries. One's eyes read depth into the relationship between dark and light, but such distance is only the merest intimation in the pictures themselves.

The relationship of darkness and illumination is also important in Meatyard's images that trace the play of sunlight on the surface of water. These are photographs of dramatic contrast, especially the ones taken after 1959, when Meatyard's long exposures and the rhythmic movements of his camera lead to sweeping arrows of light in the finished prints (plates 92 and 99). Here he used the camera somewhat in the way an Abstract Expressionist painter might use a brush or dowel, translating motion and emotion into form. As he described them, "Light alone [is] the subject of the photographs. One source, many sources—direct, reflected. Coming from within. Wherever light, is heavenly light."[29]

The other great insight Meatyard extracted from his time with Minor White in Indiana was the relationship of Zen to photography. Among the books White recommended was Eugen Herrigel's *Zen in the Art of Archery* (1953), which was later joined in Meatyard's library by nearly three dozen other titles on Eastern religions. Meatyard's Zen twigs were the clearest manifestation of this burgeoning interest (fig. 2, plate 64). They bridge the no-focus and light-on-water photographs, and consist of a broad focus-free field from which emerges the sharp, calligraphic shape of a branch or

leaf. Meatyard uses a detailed close-up view of a natural form to stand in for a greater whole. The visual energy of these crinkled lines in space can represent the energy and life force of nature itself.

Immediately following his return from Indiana, Meatyard shared with several club members the ideas he had discussed so excitedly at the workshop. He taught classes in his home, as Coke had done the year before, and in this way drew to himself a small group of open-minded photographers, including Dr. Noble Macfarlane and Cranston Ritchie. As had been the case when Coke took Meatyard under his wing, Meatyard soon mentored Ritchie.

Little is known about Ritchie, though art historian James Rhem has recently excavated several details about his life and photography.[30] Two and a half years older than Meatyard, Ritchie enrolled in the military in 1942; he earned a Purple Heart and Bronze Star for service in Europe as a parachutist with the 101st Airborne Division. Ten years later he was settled in Lexington, where he lived with his wife Martha and worked as a machine operator at Butler's Printing.[31] He began using a camera creatively not long before the private classes Meatyard gave in 1956, and he quickly became one of the club's most adventuresome artists. His rapid maturation meant that relatively conventional photographs, such as his Lexington street scenes (plate 33) and his humorous portrait of a local pet-store owner posing with a monkey, coexist with more compositionally daring, experimental pictures.

Some of Ritchie's unconventional photographs bear the imprint of Meatyard's precepts and preferred subject matter. His picture of a small animal skull and jawbone resting side by side on a pebbly blacktop calls to mind Meatyard's use of bird carcasses in some compositions. Ritchie's photograph of illegible headstones, two wrapped in shadow and a third irreparably broken, recalls his mentor's penchant for photographing cemetery statuary (plate 51). And his remarkable photograph of two twigs or branches, seemingly covered in mushrooms or spores, conjures Meatyard's Zen twigs photographs (plate 110). (It also mimics the double-helix structure of DNA, which had been revealed to the public in 1953.) Yet the club's emphasis was on individual creative expression, and soon Ritchie differentiated himself from Meatyard the way Meatyard had distinguished himself from Coke.

Meatyard acknowledged two of Ritchie's pioneering techniques. When in late 1971 the Hite Art Institute at the University of Louisville mounted an exhibition of Ritchie's photographs, in the accompanying brochure Meatyard wrote, "Besides becoming a more than apt photographer who was good enough to show nationally, [Ritchie] had developed two forms of straight photography that were uniquely and peculiarly his own. The method was to slowly rack the shutter on his Rolleiflex while tripod [sic] mounted in and out. The other was also panning the camera while doing the previously mentioned operation."[32] The panning technique results in pictures like one of Christopher Meatyard's face, in which the camera's sideways motion stretches the boy's ghostly visage across an inky black expanse. In another, three sources of light—perhaps windows veiled by thin curtains—become apparitions that stretch from the bottom to the top of the frame, *Star Trek* teleporters *avant la lettre* (plate 100). As Rhem notes, despite his proclivity for camera-motion experiments, Meatyard seems never to have copied these Ritchie techniques.

One characteristic that distinguishes many Ritchie photographs is their shallow depth of field. Ritchie often placed his lens perpendicular to his subject, and left no space at the edges of the frame for contextual information. Some of these experiments resulted in abstract textures reminiscent of Aaron Siskind's walls, with which Ritchie must have been familiar (plate 54). Others feature graphic patterns, as with his pictures of a cracked, taped-up storefront window or the spiderlike shadow cast upon an expanse of rock (plates 35–36). The sense of compression in these photographs is epitomized by another remarkable rock study featuring a small dark hole at its center (plate 48). Ritchie's tight framing makes it difficult to tell if this aperture, perhaps an opening into one of Kentucky's many caverns, is in a vertical or horizontal rock face. Every geological striation presses inward toward this breach, as if it possesses gravitational force. A wishbone-shaped twig rests on the precipice, its two "legs" balanced precariously on the edge, its "head" peering into the black abyss. Here is a tough-minded, partly abstract composition that upon closer study discloses equally tough-minded metaphorical content.

That toughness—that absence of lyricism—marks Ritchie's best work. Who would have expected a dedicated amateur, working in Kentucky

during the late 1950s, to create a picture as remarkable as Ritchie's study of ground ties emerging jaggedly from the ground, twinned by equally dark shadows? The rumpled lines these wires draw are mirrored yet again by the cracks in the earth's baked surface. *Ground Ties* (plate 59) is evidence of a creative sensibility open to seeing how the camera sees.

Sometime during the late 1950s, doctors pronounced a tumor in Ritchie's right hand to be malignant, and conducted several unsuccessful operations to stave off the cancer's spread. Those who know about Ritchie today likely know him not for his own work but from Meatyard's famous 1958–59 portrait of him (fig. 5). Ritchie stands against a wall, next to a headless dressmaker's form and a blank mirror. The lower half of his right

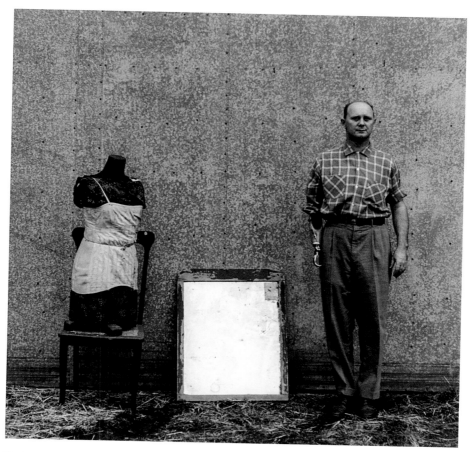

Fig. 5 Ralph Eugene Meatyard, *Untitled [Cranston Ritchie]*, 1958–59. Gelatin silver print, 6¾ x 6⅞ in. (17.1 x 17.5 cm). Courtesy Fraenkel Gallery, San Francisco.

arm has been replaced by a prosthetic hook. He stares forthrightly at the camera, undaunted by illness.

Ritchie's artistic blossoming was cut short by his cancer, which killed him at age thirty-eight on December 26, 1961. The archive of his negatives numbers just over eight hundred frames, orders of magnitude fewer than Meatyard's eighteen thousand. Though it spanned only five years, his development as an artist echoed that of the club's most intrepid members during the 1950s. Ritchie was occupied by a day job, shooting and developing prints mostly on the weekends. He photographed in and was inspired by Lexington and its environs. He was nurtured by a mentor and benefited from the club's dedication to individualistic expression. Ritchie's exceptional artistic achievement in this context is a function of, and testament to, these conditions. He may have been geographically sequestered, but he was artistically liberated. This balance of isolation and artistic emancipation in Lexington would shift in the decade that followed, as the club's reputation swelled.

———

During the 1960s a growing number of artists and writers settled in or passed through Lexington. This was part of a broader trend: the city itself grew in population by more than 70 percent during the decade.[33] The traditional industries on which the city's gentility rested were horses, bourbon, coal, and tobacco—each of which prospered as part of a strong postwar American economy.[34] The university was the largest local employer, but in 1956 IBM opened a major typewriter-manufacturing plant that would expand over the decades to employ as many as 6,000 people. (Club member Robert C. May began work at IBM in 1967.) Its presence reshaped large swaths of the city's northern neighborhoods.[35]

Despite the city's rapid growth, Lexington's manageable scale helped ensure that men and women interested in the arts came to know one another. Farmer and writer Wendell Berry demonstrates the ease of such encounters by describing how he met Meatyard. "It must have been about 1966. Jonathan Williams was visiting the University of Kentucky. One night he showed his slides of artists and writers, and among these was one of the Lexington photographer Ralph Eugene Meatyard. As I was walking out

of the theater with James Baker Hall, he said he wished he could get to know Gene Meatyard, and Gene, who happened to be walking in front of us, turned around and stuck out his hand."[36] Meatyard soon invited Berry and Hall to his home for dinner.

Such invitations bound together a remarkable artistic and intellectual community that grew with each passing year. The roll call seems preposterously long for that time and place. Guy Davenport, after receiving an education at Duke, Oxford, and Harvard and teaching for two years at Haverford College, joined the University of Kentucky faculty during the fall of 1963. Williams, whom Davenport had met the year before at Haverford, took him to the Meatyards' home to introduce him to the photographer, and brought along poet Ronald Johnson, filmmaker Stan Brakhage, and librarian Bonnie Jean Cox, who would become Davenport's partner of forty years.[37] Davenport's temperament urged him "to retreat, to cloister, to isolate himself from the judgment of his colleagues and his neighbors." And yet "during the '60s, he seemed to very much value his friendships" with Meatyard and Thomas Merton.[38]

Wendell Berry returned to the University of Kentucky, where he had studied during the mid-1950s, the same year as Davenport. Like Davenport, he also had traveled widely. Berry had received a Wallace Stegner Fellowship to study at Stanford and a Guggenheim Fellowship that took him to Italy and France, and had spent two years teaching in New York. The new faculty members had neighboring offices on the university campus. "By walking a few steps and leaning on his doorjamb, saying a word or two of greeting, I could start Guy decanting whatever happened to be on his mind," Berry later recalled. "But my metaphor is off. The flow started not from a decanter but from a stream, and somewhere upstream it was raining."[39] As he wrote more recently, "In 1964, for a young writer in Kentucky and in need of sustenance, sustenance was here."[40]

In 1965 the university marked its centennial with lavish celebratory events. Davenport was in charge of inviting speakers in the arts and the humanities, and his choices brought an avant-garde accent to the conversation in Lexington. Brakhage returned, and the poet Louis Zukofsky, the writer Eudora Welty, and the scientist and inventor Buckminster Fuller all came to speak. They too were likely brought around for home-cooked meals. That same year the young poet Jonathan Greene launched Gnomon

Press, and in 1966 he moved to Lexington. He would publish Meatyard's first monograph in 1970, as well as, throughout his career, books by Berry, Williams, photographer Guy Mendes, and others with connections to the region.

These new arrivals encountered not only the Lexington Camera Club and its most enterprising members, but also a coterie of talented artists working in adjacent disciplines. John Jacob Niles, the celebrated singer, composer, and compiler of American folk music, lived half an hour to the east on a farm in Clark County (plates 4, 19, and 23). Merton was still in his hermitage, writing feverishly and welcoming anyone he could sneak past the abbey's leadership. Austrian-born artist, printer, and typographer Victor Hammer arrived in Lexington in 1948 to be artist-in-residence at Transylvania University. (He was especially close with Merton, often printing limited-edition versions of the monk's writings.) Hammer married Carolyn Reading, who was herself the proprietor of Bur Press; she founded the King Library Press at the university in 1956. The couple's work stimu-lated a fine-press-printing community that included such figures as Gray Zeitz, whose Larkspur Press published books and broadsides by Davenport, Berry, Greene, James Baker Hall, and others.[41] And the university had an art department with a faculty that included, at various points, Raymond Barnhart, who had studied with László Moholy-Nagy in Chicago and Josef Albers at Black Mountain College; Frederic Matys Thursz, a painter of abstract monochromes who exhibited widely and later divided his time between New York and Paris; and Clinton Adams, a painter and print-maker who later founded the influential Tamarind Institute. The Lexington Camera Club's local context was rich, varied, and galvanizing.

Meatyard linked the Club to the broader world of fine-art photography. While New York City is indisputably the American capital of art photogra-phy today, during the 1950s and 1960s it was only one of several regional concentrations of photographic talent.[42] Rather than the hub-and-spoke arrangement that defines today's cosmopolitan art world, or at least some people's narrow (and increasingly outdated) view of it, artistically inclined Lexington Camera Club members saw themselves as comprising one node in a relatively undifferentiated network, a light as bright as any others on the same string. As early as 1959, Meatyard claimed, "The Lexington Camera Club makes up a large group of the creative [photographers] in

the U.S. and for this reason we work harder and probably more intensely on our art than in any other area to maintain our position and to keep our part of the country—the entire South—on a high level of creativity in photography as an art."[43]

The photography community's pluralism during this era was supported from numerous directions. Camera clubs were, of course, part of the equation. So too was the new Society for Photographic Education, which passed its bylaws in 1964, and fledgling academic programs— in such diverse locales as Los Angeles; Champaign-Urbana, Illinois; Providence, Rhode Island; and Gainesville, Florida.[44] Also useful was the ease with which prints, often no larger than eleven by fourteen inches, could be sent through the mail for exhibition in far-flung galleries. These developments were contextualized in new, nontechnical photography publications like *Aperture*, founded in 1952.[45] The Lexington Camera Club, led in spirit (if not always officially) by Meatyard, tapped into this network increasingly as the 1960s wore on.

Journalist Joyce Todd demonstrated Meatyard's familiarity with this national scene in a 1966 article. She paraphrases his taxonomy:

> There are five main areas of fine photography in the United States. . . . The *New York City group* is characterized by pictures which are fairly close-up shots of people or things. The *Rochester/ Boston group* is noted for close-to-medium pictures of things and patterns with less emphasis on people. In the *West Coast group*, the open, scenic type has the appearance of more freedom than in the other areas—for example, the followers of Adams and Weston who do both landscape and abstracted earth photographs. The reportorial type of photography dominates in the *Chicago group*. People are shown not so much in close-up as in the New York group but more in relation to their location . . . a man walking down the street, a black street with brilliant light, etc. Patterns are clearly an influence.[46]

Meatyard was not coy about Lexington's place in this firmament: "Uniquely, the *Lexington group* is the broadcaster of a different, super-real world."[47] (His phrasing suggests he's speaking as much about himself as

his compatriots, many of whom had different ideas about what photography could or should do.) Nor was he afraid to mingle Lexingtonians' work with the best being produced around the country. In 1967 he opened his own shop, Eyeglasses of Kentucky, which presented rotating displays of art in the waiting room—photographs by Camera Club members and by Emmet Gowin, Paul Caponigro, Nathan Lyons, and Aaron Siskind, drawings by Thomas Merton, paintings by Frederic Thursz—alongside unusual reading material, like the *Hudson Review* or *Monk's Pond*, Merton's self-published literary magazine.[48]

Several of these photographers reappeared in three large invitational exhibitions sponsored by the club, which harkened back to Van Deren Coke's *Creative Photography 1956* and complemented the annual members-only shows. Arranged by Meatyard, *Photography 1968*, *Photography 1970*, and *Photography "72"* paired selected club members' work with prints by faculty and students from prominent photography schools.[49] The first two exhibitions were held at Transylvania University's brand-new Morlan Gallery. (The university had been home to the club's monthly meetings since 1967.)[50] *Photography "72,"* a massive presentation of 240 prints, was held at Louisville's Speed Art Museum—evidence of the club's increasing regional prominence and, more generally, the elevation of photography to fine-art status.

———

The club's vigorous activity drew a new generation of photographers into its orbit. By the mid-1960s, it seems, any young Kentuckian interested in photography was directed to a club meeting or to Lexington's Imperial Plaza Shopping Center, where Eyeglasses of Kentucky was located. These newcomers were welcomed warmly, and their ideas and aspirations taken seriously. Fred W. Steffen joined in the mid-1960s and quickly became Club Secretary, printing a monthly newsletter mailed to roughly thirty active members, participating in both members-only and invitational exhibitions, and devising an experimental catalogue design for *Photography 1970*. Charles Traub, a Louisville native two decades younger than Meatyard, recalls meeting the older photographer in late 1967 or early 1968: "He was encouraging and immediately invited me to be part of an exhibition which

he was holding in the little lobby of his place."[51] Traub also participated in *Photography 1968.* Meatyard and May began traveling regularly to Louisville to hold club-style critique sessions with Traub, University of Louisville art department head Robert J. Doherty, and others. Guy Mendes, who enrolled at the University of Kentucky to study journalism and took a writing course with Wendell Berry, later said, "I think [Meatyard] was genuinely interested in the works that people brought to him."[52] Mendes frequently went out shooting with Meatyard during the late 1960s and early '70s; he became an active club member and participated in *Photography "72."*

Both Traub and Mendes came to photography through writing, and both pushed through their attraction to Meatyard's photographs on the way to developing individual styles. They worked "straight," in the parlance of the day, largely avoiding their mentor's techniques for creating a "different, super-real world." In the late 1960s Traub was more visibly under Meatyard's sway, his subjects drawn from familiar territory: a rubber boot isolated against asphalt; a severed hand, seemingly from a sculpture or sign, resting in the grass; a dead bird in the snow; woodland scenes viewed from within abandoned buildings. But, as he later recounted, Traub's time as an English major helped him "to discover that you could make metaphors or equivalences of your own experience that were not literal."[53] He was making pictures every day, broadening his horizons. As he realized that "photography is about seeing what the world looks like as a picture,"[54] his own vision came into focus. The world seen through his camera was even-toned, often somber, and occasionally pierced by shafts of light (plate 42). People are rarely incidental aspects of Traub's early photographs; they're either the subject, centrally placed, or beyond the frame. He possessed a particular talent for evoking a building's interior through deftly chosen details—a chandelier missing one bulb, a clock resting on the mantel just off center (plate 80). Working outdoors, he treated the natural environment as a series of design problems to solve, using his square-format camera to explore not only particular Kentucky places but also pattern and composition. "I don't even know if we really should call them landscapes," he recalled. "Rather, they are abstractions of trees that deal with the edge-to-edge problem."[55]

If the literary technique Traub brought to photography was the metaphor, Mendes used the camera to expertly sketch characters. He was,

after all, a journalism student, used to the confines of column inches. (After some typical 1960s-era student activism, Mendes and some fellow staffers were kicked off the University of Kentucky student newspaper, and in reaction he founded the *blue-tail fly*, which ran for eleven issues and presented portfolios by Meatyard and Gowin, among others.)[56] His photographs of place can be evocative, as with *Madison Place Porch, Lexington, KY* (plate 56) or *Tenant House, Elms Farm, Woodford County*, which communicate ample information—about living simply, making do with what you've got—despite one being a close-in view and the other a broader vista. But Mendes's greatest strength is as a portraitist; his best photographs capture their subjects' characters with the precision of a lepidopterist pinning butterfly specimens in a case. The curve of Miss Hattie's tight smile (plate 25) exactly matches Richard Nixon's on the giant button affixed to her chest. A halo of light fairly explodes from Ed McClanahan's head (plate 27), hinting at the "sike-o-deelic refugee from a Smirnoff ad" the writer later admitted was the character he played during the era.[57] And of course there is the louche charm in Mendes's motel-room portrait of Williams (fig. 6), in which the subject's honest gaze belies his slightly absurd circumstances.

Mendes spent many hours in Meatyard's company during these years. Perhaps the only photographer who logged more time with Meatyard was his old friend May. For most of their two-decade friendship, their photographic styles diverged. Although May attended the 1955 workshops with Van Deren Coke that had pushed Gierlach and Meatyard in experimental directions, he had continued along a more traditional path, looking to photographers like Henri Cartier-Bresson for inspiration. He was after the "decisive moment" and did not construct scenes for the camera. For more than a decade May worked as a staff photographer for the University of Kentucky's Agricultural Experiment Station, which allowed him to make landscape scenes throughout the state. But when he left that position to join IBM in 1967, May's creative photography changed dramatically. His "straight" images became increasingly complex, as in the remarkable play of angular shadows and textures in *Untitled [Dark shadows on building]* (fig. 7). He also began making multiple-exposure photographs, both in Lexington and on the edges of town. The best such works, like *Untitled [Fence, lanterns, and figures]* (see cover), fuse dissimilar subjects into a

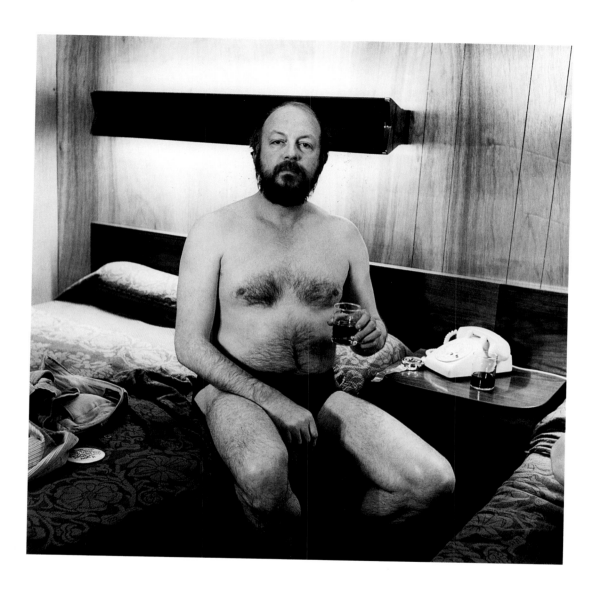

Fig. 6 Guy Mendes, *Jonathan Williams at Zoder's Best Western, Gatlinburg, TN*, 1974. Gelatin silver print, 12½ x 12½ in. (31.8 x 31.8 cm). Courtesy of the artist.

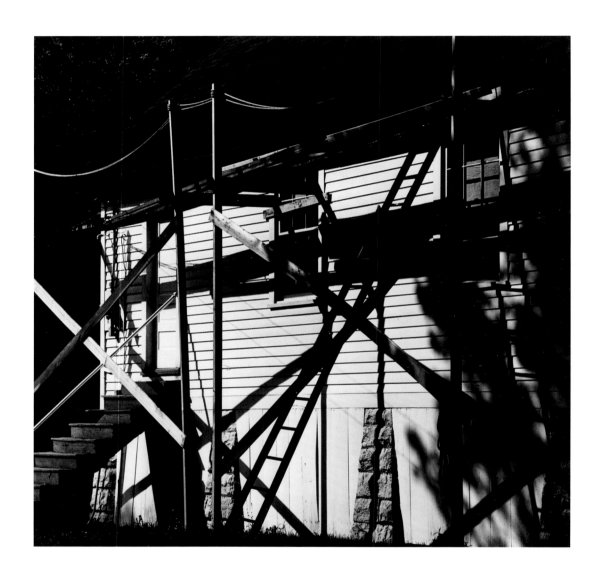

Fig. 7 Robert C. May, *Untitled [Dark shadows on building]*, 1967. Gelatin silver print, 5¹¹⁄₁₆ x 5¾ in. (14.5 x 14.6 cm). The Art Museum at the University of Kentucky, Lexington.

surreal whole. After more than a decade shooting at Meatyard's side, May's work hewed more closely to that of his friend. But, as James Baker Hall would write, these pictures "acknowledge their source in Meatyard's work with the confidence of a man who knows his own signature. Unlike his mentor's similar images, where displaced registration speaks of mutability and decay, May's landscapes—elegant, precise, scrupulous, formal—are responsive to the beauty of the garden apple, not the worm."[58]

———

Hall, a poet, novelist, and champion of photography, did not primarily identify as a photographer. Thanks to a family connection, however, he had been using a camera since childhood. After graduating from the University of Kentucky and studying writing at Stanford (as had Wendell Berry), he lived between Lexington and New England and taught both English and photography. He made tender portraits of writers, friends, and family; sly, funny pictures of animals; and, like many associated with the club, experimental views of the Kentucky landscape. Hall used shadows and the edges of the frame with particular skill, often inserting himself into the scene he photographed. (In this, his photographs were of the moment; Lee Friedlander's famous self-portrait, in which his shadow is thrown onto the golden hair and fur coat of a woman ahead of him on a New York City sidewalk, was made in 1966.) In the foreground of one untitled woodland scene made in 1973, two tree trunks, slightly out of focus, bisect the frame; Hall's distinctive shadow falls across them (plate 40). Peering through the narrow gap between them, as Hall does, one sees a cow standing incongruously in the distance. Hall's silhouette, stretched by slanting light, reappears in several other photographs (plate 39). And a shadow seen from the other direction, the source of light behind the subject, makes Hall's ca. 1974 portrait of Bob May more compelling (plate 5). Hall, who led the creative writing department at the University of Kentucky from 1973 to 2003, would take his photographic talent in other directions in the decades to come. He eventually approached the medium like a painter; the image was merely a starting point, subject to manipulation. But in the early 1970s he captured visual incongruities with cunning artfulness, and

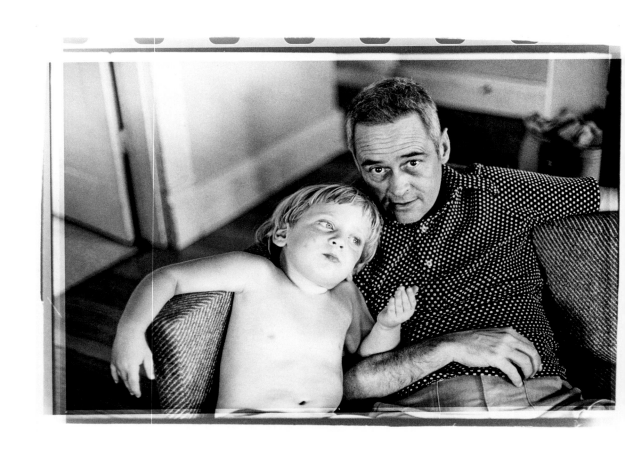

Fig. 8 James Baker Hall, *Gene and Michael*, ca. 1972. Gelatin silver print, 8¼ × 12½ in. (21 × 31.8 cm). James Baker Hall Archive of Photographs and Films, Lexington.

paired those images with portraits of family and friends that are disarmingly loving.

Hall's portrait of his son Michael on the couch with Meatyard (fig. 8) attests to this talent, and to the friendship that accompanied their mutual admiration as artists. Indeed, nearly all these men photographed each other; it can be understood as part of the dictum, passed down from Van Coke, to make art out of what was immediately at hand. Meatyard made more photographs of Thomas Merton than of any other person.[59] (His first pictures of "Tom" were taken on the afternoon they met.) Merton, like Hall, did not identify primarily as a photographer. And again, like Hall, Merton took photography very seriously. The civil-rights photojournalist John Howard Griffin, whose first encounter with Merton was a portrait session, encouraged Merton's use of the camera. In fact, he enabled the monk's increasing fascination with the medium by lending or giving him cameras and printing many of Merton's photographs in his own darkroom.[60]

The pictures Merton took acted as a corollary to his writing, in that they too aim for a heightened awareness of a given moment. They are instances of visual contemplation, and most often take the form of still lifes or close-in views of the abbey's grounds.[61] "I belong to this parcel of land with rocky rills around it, with pine trees on it. These are the woods and fields that I have worked in, and walked on, and in which I have encountered the deepest mystery of my own life."[62] The puzzle of existence seems to have dwelt in branches, shadows, and patches of light on his cell's bare walls (plates 52–53 and 62–63). His advice to poet Ron Seitz about the art of photography suggests not only Zen precepts but also the originating impulse of Meatyard's no-focus photos: "When photographing . . . stop *looking* and . . . begin *seeing*! Because looking means that you already have something in mind for your eye to find; you've set out in search of your desired object and have closed off everything else presenting itself along the way. But seeing is being open and receptive to what comes to the eyes; your vision total and not targeted."[63]

———

Total vision: Meatyard's eye was so keen that he could not only extract photographs from the landscape but also resituate them when he visited someplace he'd seen earlier in a picture. Davenport tells another story from the day Meatyard and Merton met: "Gene had begun the conversation as we got out of the car. His incredibly sharp eyes had seen a rock by a pine tree near the cabin porch, and he remarked casually that it had been photographed by someone and used on the cover of a New Directions book. Tom had taken the picture. So they first met as fellow photographers."[64]

On that day, it would have been impossible to imagine that Merton would die less than two years later at age fifty-three, electrocuted while traveling in Thailand. Or that cancer would kill Meatyard, less than four years after that, at age forty-seven. Both were nearing the peak of their creative powers, ferociously active. In the time that remained to them, both reaffirmed the fraternal bonds that tied them to those whose intellect and companionship sustained their artistic lives, in Lexington and beyond. Merton corresponded with hundreds of friends and welcomed many who made it to the abbey's remote premises. Meatyard spent several years each on two remarkable, and remarkably different, photographic series. One was published as *The Family Album of Lucybelle Crater* by Jonathan Williams's Jargon Society in 1974; it is probably the work that has garnered him his greatest posthumous fame. It's a compendium of sixty-four square-format pictures of family and friends; in each picture but the last, Meatyard's wife, Madelyn, appears in a garish mask alongside a different person wearing a semitransparent old man's mask. The *Album* is remarkable for the psychological and narrative complexity it wrings from so simple a premise.

For the other series, Meatyard spent two years hiking the Red River Gorge with Wendell Berry, producing an astonishing suite of landscape photographs published in 1971 as *The Unforeseen Wilderness* (plates 69–72).[65] The pictures, as he sequenced them, travel from the river's edge up through the gorge, ending at the top of ridges, a carpet of trees tracking back into the far distance. "As I look now at his Red River photographs I am impressed as never before by their darkness," Berry noted when revisiting the series in 1990.[66] These were honest, unsparing visions of a threatened place, not vistas of sylvan charm.

The two series are dissimilar on the surface: a suite of snapshot-style portraits and an unpeopled set of Kentucky landscapes. But both are sequences of about sixty pictures, and both extract from unpromising genre constraints photographs of radical uneasiness. Something is mercurial in both projects. James Baker Hall, perhaps influenced by Meatyard's untimely death and the loss of other loved ones, felt similarly: "The nature pictures are as dark and ominous, full of mystery, and touched by doom as the story pictures."[67]

There is a tale, often told, about Meatyard's ambition: In his own copy of Beaumont Newhall's *The History of Photography: From 1839 to the Present Day*, Meatyard dry-mounted his photograph *Romance (N.) from Ambrose Bierce #3* as a new frontispiece. Newhall, the first director of the Museum of Modern Art's photography department, which has famously been described as the "judgment seat of photography," found no place for Meatyard's work, even in revised editions of his canonical narrative.[68] Nonetheless *Lucybelle*, and the Aperture monograph that James Baker Hall helped shepherd into print in the same year, secured Meatyard's place in the history of American photography.[69]

Meatyard was a central presence in the Lexington Camera Club from the late 1950s until his death. As Guy Mendes noted recently, "When [Gene] died, the Camera Club died, too. After thirty-six years of once-a-month meetings, going back to the mid-1930s, the flame was extinguished."[70] Yet in March 2014 Mendes and a group of like-minded photographers resuscitated the name; the new Lexington Camera Club has met and exhibited regularly ever since. It seems an appropriate moment, then, to revisit the original club. Its most artistically inclined members merit sustained inquiry, whether they sought no broader fame for their work, or died too young to fully develop their talents, or are better known for other contributions to the arts. Meatyard certainly thought so. For example, he was the one who helped place Cranston Ritchie's archive at the University of Louisville. After describing his friend's pioneering techniques in the 1971 exhibition dedicated to Ritchie's work, Meatyard appended this comment: "He will certainly be recognized in years to come as an outstanding individual photographer as many of the 19th-century men are being recognized today."[71]

Modern critical impulses have prompted us to see stories like Newhall's as being what they are—stories, authored from particular, and limited, vantage points. Historians have expanded their narratives to include Meatyard's remarkable achievements. His own confidence and aspiration helped; after all, he made sure to send his exhibition catalogues to John Szarkowski, who at the time held Newhall's seat at MoMA.[72] To us, Ralph Eugene Meatyard can seem a figure as remote and strange as his unusual name. But among club members and his friends in Lexington, Meatyard was just Gene. James Baker Hall was Jim. Thomas Merton was Tom. Robert C. May was Bob. Recovering the warmth of their friendships, the importance of the place where they lived, and the creative reciprocity embodied in the Lexington Camera Club brings several welcome effects. Doing so tells us more about a figure we already know. It also elevates a remarkable group of artists too long in his shadow. And it reminds us of the power of community to shape even the most singular of artistic visions.

NOTES

1. Guy Davenport, "Jonathan Williams," in *The Geography of the Imagination: Forty Essays* (Boston: David R. Godine, 1997), 180–89. Davenport's description of the Beetle is found in "Ralph Eugene Meatyard," in *The Guy Davenport Reader*, ed. Erik Reece (Berkeley, CA: Counterpoint, 2013), 267–72. Guy Davenport, *Flowers and Leaves: Poema vel sonata, carmina autumni primaeque veris transfortionum* (Highlands, NC: Jargon Society, 1966).

2. Guy Davenport, interview by Barbara Tannenbaum, April 25, 1990, 1, Akron Art Museum Archives.

3. Stephen Reily, foreword to *Meatyard/ Merton, Merton/Meatyard: Photographing Thomas Merton* (Louisville, KY: Fons Vitae, 2013), n.p.

4. Davenport, interview.

5. The philosophy was important to both of them. Among other lessons drawn from its tenets, "both sensed that preconceptions . . . blind the individual from a real and meaningful experience of universal humanity." Chris Meatyard, "Zen Camera," in *Meatyard/ Merton*, n.p.

6. Thomas Merton, *Learning to Love: Exploring Solitude and Freedom*, ed. Christine M. Bochen (San Francisco: HarperSanFrancisco, 1997), 186.

7. Ralph Eugene Meatyard, "Photographing Thomas Merton: A Reminiscence," in *Father Louie: Photographs of Thomas Merton by Ralph Eugene Meatyard*, ed. Barry Magid (New York: Timken, 1991), 39.

8. In a letter to Jonathan Williams dated May 24, 1967, Meatyard writes, "Have been spending a number of enjoyable times with Father Louis. 3 times there. Twice here, + twice in Louisville." PCMS-0019, Jargon Society Collection, 1950–2008, Poetry Collection, State University of New York at Buffalo (hereafter cited as Jargon Society Collection).

9. Ralph Eugene Meatyard to Thomas Merton, August 12, 1967, Record Group A, Thomas Merton Center at Bellarmine University.

10. Thomas Merton to Ralph Eugene Meatyard, August 15, 1967, Meatyard Archive.

11. See, for instance, "Fifth Period of Snapshot-Contest Competition Ends at Midnight Monday," *Lexington Herald-Leader*, July 4, 1954; "Weekly Winners," *Lexington Herald-Leader*, July 18, 1954; and "Grand Prize Winners," *Lexington Herald-Leader*, August 1, 1954. Coke's grand-prize-winning photograph of a man outdoors, in middle distance, seated in profile and resting his forehead in his hand, is far removed from the pictures of a young girl playing with a stethoscope, a candle, and puppies in a cardboard box that also won prizes.

12. The best and most thorough source on the history of the Lexington Camera Club is Robert C. May, *The Lexington Camera Club, 1936–1972* (Lexington: University of Kentucky Art Museum, 1989).

13. On the Photographic Society of America, see the organization's website, https://www.psa-photo.org/index.php?about-history-of-psa, and Michael S. Griffin, "Amateur Photography and Pictorial Aesthetics: Influences of Organization and Industry on Cultural Production" (PhD diss., University of Pennsylvania, 1987).

14. The biographical and critical literature on Ralph Eugene Meatyard is vast, but I am particularly indebted to Barbara Tannenbaum, ed., *Ralph Eugene Meatyard: An American Visionary* (Akron, OH: Akron Art Museum; New York: Rizzoli, 1991); *Ralph Eugene Meatyard* (New York: International Center of Photography; Gottingen, Germany: Steidl, 2004); and Eugenia Parry and Elizabeth Siegel, *Ralph Eugene Meatyard: Dolls and Masks* (Chicago: Art Institute of Chicago; Santa Fe, NM: Radius Books, 2011).

15. *Focus on Lexington and Fayette County* (Lexington: Art Gallery of the University of Kentucky, 1954).

16. This description of club meetings is drawn from May, *Lexington Camera Club*.

17. Typescript of class handout, Meatyard Archive.

18. Ibid.

19. Gierlach's observations about his abstract photographs come from hand-written notes in Boxes 1 and 3, Collection on the Lexington Camera Club, 1936–1972, University of Kentucky Special Collections. His bookplate, bearing the slogan "Patron of Art," is found in Box 3.

20. Ralph Eugene Meatyard, "Remembering F.v.d.C.," *Kentucky Review*, Autumn 1968, 49.

21. Van Deren Coke, "The Photographs of Eugene Meatyard," *Aperture* 7, no. 4 (1959): 158.

22. Photographer Roy DeCarava and his wife Anne opened A Photographer's Gallery in their Upper West Side townhouse in 1955. The gallery remained open for nearly three years. For a complete list of its exhibitions, see Peter Galassi, ed., *Roy DeCarava: A Retrospective* (New York: Museum of Modern Art/Harry N. Abrams, 1996), 269–70.

23. See *Aperture* 4, no. 1 (1956): 4–29.

24. For a useful introduction to Richards, see Terry Eagleton's assessment of his works: "A Good Reason to Murder Your Landlady," *London Review of Books* 24, no. 8 (April 25, 2002), http://www.lrb.co.uk/v24/n08/terry-eagleton/a-good-reason-to-murder-your-landlady.

25. For more, see Henry Holmes Smith, "The Education of Picture-Minded Photographers: A Symposium, Part 3," *Aperture* 5, no. 1 (1957): 24–28.

26. Ralph Eugene Meatyard, unpublished draft of lecture delivered to the Louisville Photographic Society, 1959, Meatyard Archive.

27. Ralph Eugene Meatyard to Jonathan Williams, March 19, 1962, Jargon Society Collection.

28. Ralph Eugene Meatyard to Henry Holmes Smith, February 27, 1959, cited in Tannenbaum, *Ralph Eugene Meatyard*, 30.

29. Ralph Eugene Meatyard, unpublished draft of lecture delivered to the Louisville Photographic Society, 1959, Meatyard Archive.

30. Most biographical details are drawn from *Cranston Ritchie: Gene's Friend*, a brochure accompanying a 2015 exhibition curated by James Rhem and Bill Carner for the University of Louisville Photographic Archives.

31. *Polk's Lexington City Directory* (Lexington, KY: R. L. Polk, 1952), 209. Digital image, *U.S. City Directories, 1822–1995*, Ancestry.com.

32. *Cranston Noah Ritchie: Photography*, exhibition brochure, Allen R. Hite Institute Gallery, University of Louisville, 1971, http://digital.library.louisville.edu/cdm/ref/collection/hite/id/518.

33. This information is drawn from the decennial US Census of population and housing, http://www.census.gov/prod/www/decennial.html.

34. See chapter 19 in Lowell H. Harrison and James C. Klotter, *A New History of Kentucky* (Lexington: University Press of Kentucky, 1997).

35. Cheryl Truman, "Uncommonwealth: Remembering the Impact of IBM in the Midst of Lexmark Layoffs," *Lexington Herald-Leader*, September 16, 2012, http://www.kentucky.com/news/business/article44377293.html.

36. Wendell Berry, "Remembering Gene Meatyard," in Tannenbaum, *Ralph Eugene Meatyard*, 83.

37. Davenport, "Ralph Eugene Meatyard," 267.

38. Erik Reece, "Afterword: Remembering Guy Davenport," in *The Guy Davenport Reader* (2013), 414, 416.

39. Greg Kocher, "A Human and Literary 'Miracle' Remembered," *Lexington Herald-Leader*, May 8, 2005, http://www.geocities.ws/chuck_ralston/07_dav-memorial.htm.

40. Wendell Berry, "Kentucky Writers in Kentucky," *Appalachian Heritage* 43, no. 1 (Winter 2015), http://appalachianheritage.net/2015/02/06/kentucky-writers-in-kentucky-a-special-feature-by-wendell-berry/.

41. For more on this subject, see Burton Milward, "The Private Press Tradition in Lexington, Kentucky," *Kentucky Review* 11, no. 3 (Autumn 1992): 5–27.

42. See, for example, Jessica S. McDonald, "Centralizing Rochester: A Critical Historio-graphy of American Photography in the

1960s and 1970s" (PhD diss., University of Rochester, 2014).

43. Ralph Eugene Meatyard, typescript of lecture delivered to the Louisville Photographic Society, 1959, 13, Meatyard Archive.

44. Society for Photographic Education, "History," https://www.spenational.org/about/history.

45. See Peter C. Bunnell, ed., *Aperture Magazine Anthology: The Minor White Years, 1952–1976* (New York: Aperture, 2012).

46. Joyce Todd, "Town Meets Gown," *Accent* 1, no. 1 (October 1966): 12–13.

47. Ibid., 13.

48. Charles Traub, interview by Barbara Tannenbaum, February 16, 1990, 2, Akron Art Museum Archives; Merton and Thursz information comes from Christopher Meatyard, e-mail to the author, January 25, 2016; information about the reading material comes from Guy Mendes, interview by Barbara Tannenbaum, April 24, 1990, 3, Akron Art Museum Archives.

49. The schools: George Eastman House, Indiana University, University of New Mexico (1968); Ohio University, Rhode Island School of Design, UCLA (1970); MIT, University of Illinois, University of Louisville, and University of Nebraska (1972).

50. May, *Lexington Camera Club*.

51. Traub, interview by Tannenbaum, 2.

52. Mendes, interview, 26, 27.

53. Charles Traub, interview by Phong Bui, *The Brooklyn Rail*, May 2011, http://www.brooklynrail.org/2011/05/art/charles-traub-with-phong-bui.

54. Ibid.

55. Ibid.

56. High-resolution scans of the *blue-tail fly* are available on the Explore UK website, http://exploreuk.uky.edu/catalog/xt7pg44hn30w/guide.

57. Ed McClanahan, foreword to *Guy Mendes: Light at Hand; Photographs, 1970–1985* (Frankfort, KY: Gnomon Press, 1986), n.p.

58. James Baker Hall, "Robert May," *American Photographer* (August 1979), 62.

59. See Magid, *Father Louie*.

60. Griffin tells the story of their friendship and Merton's increasing avidity for the camera in "Les Grandes Amitiés," *Continuum* 8 (Summer 1969), 286–94. It should be noted that although Merton was friendly with several Camera Club members, he never formally joined the group.

61. For critical appreciations of Thomas Merton's photographs, see John Howard Griffin, *A Hidden Wholeness: The Visual World of Thomas Merton* (New York: Houghton Mifflin, 1970) and Deba Prasad Patnaik, *Geography of Holiness: The Photography of Thomas Merton* (New York: Pilgrim Press, 1980).

62. Thomas Merton, *Conjectures of a Guilty Bystander* (New York: Crown, 2009; orig. 1966), 259.

63. Ron Seitz, *Song for Nobody: A Memory Vision of Thomas Merton* (Liguori, MO: Triumph, 1993), 133–34.

64. Guy Davenport, "Tom and Gene," in Magid, *Father Louie*, 24.

65. Meatyard's work on *The Unforeseen Wilderness* began as early as Spring 1968, as evidenced in a letter to Jonathan Williams dated April 11, 1968, Jargon Society Collection.

66. Wendell Berry, "Remembering Gene Meatyard," in *The Unforeseen Wilderness: Kentucky's Red River Gorge* (1971; reprint, San Francisco: North Point Press, 1991), xi–xii.

67. James Baker Hall, interview by Barbara Tannenbaum and David L. Jacobs, 9, Akron Art Museum Archives.

68. Christopher Phillips, "The Judgment Seat of Photography," *October* 22 (Autumn 1982): 27–63.

69. Ralph Eugene Meatyard and James Baker Hall, *Ralph Eugene Meatyard* (Millerton, NY: Aperture, 1974).

70. Guy Mendes, "Waybackstory," typescript of a lecture delivered in Lexington, KY, August 2015.

71. *Cranston Noah Ritchie*.

72. John Szarkowski to Ralph Eugene Meatyard, March 30, 1968, Meatyard Archive.

People

Plate 1 Ralph Eugene Meatyard, *Untitled [Van Deren Coke]*, ca. 1956. Gelatin silver print, 7 x 9⅞ in. (17.8 x 25.1 cm). Courtesy Fraenkel Gallery, San Francisco.

Opposite: Plate 2 Van Deren Coke, *Slat House—Hillenmeyer Nurseries, Sandersville Road*, undated (probably 1956). Gelatin silver print, 9½ x 7½ in. (24.1 x 19 cm). University of Kentucky Libraries Special Collections Research Center, Lexington.

Following pages: Plate 3 Guy Mendes, *Passing Through [Ralph Eugene Meatyard], Powell County, KY*, 1970. Gelatin silver print, 6 x 8⅜ in. (15.2 x 21.3 cm). Courtesy of the artist.

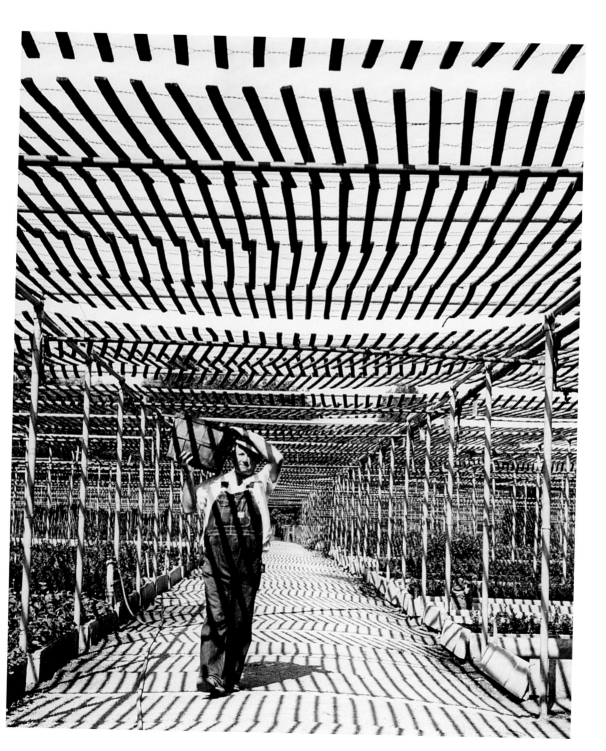

Plate 4 Van Deren Coke, *Impression of John Jacob Niles*, 1963. Gelatin silver print, 9$\frac{1}{16}$ x 7$\frac{5}{16}$ in. (23 x 18.6 cm). The Art Museum at the University of Kentucky, Lexington.

Following pages: Plate 5 James Baker Hall, *Portrait of Bob May*, ca. 1974. Gelatin silver print, 9 x 13$\frac{7}{16}$ in. (22.9 x 34.1 cm). Cincinnati Art Museum: FotoFocus Art Purchase Fund, 2016.27.

Plate 6 Guy Mendes, *Guy Davenport, with Manuscript, Lexington, KY*, 1975. Gelatin silver print, 8¾ x 8¾ in. (22.2 x 22.2 cm). Courtesy of the artist.

Plate 7 Jonathan Williams, *Guy Davenport*, after 1961. Color transparency. Yale Collection of American Literature, Beinecke Rare Book and Manuscript Library.

Plate 8 Charles Traub, *Shelbyville, Kentucky*, 1968. Gelatin silver print, 6 x 8¾ in. (15.2 x 22.2 cm). Courtesy of the artist.

Plate 9 Jonathan Williams, *Ralph Eugene Meatyard*, ca. 1967–72. Color transparency.
Yale Collection of American Literature, Beinecke Rare Book and Manuscript Library.

Following pages: Plate 10 Guy Mendes, *Torso on Aunt Zoe's Farm, Jessamine County, KY*, 1969.
Gelatin silver print, 12⅛ x 17⅜ in. (30.8 x 44.1 cm). Courtesy of the artist.

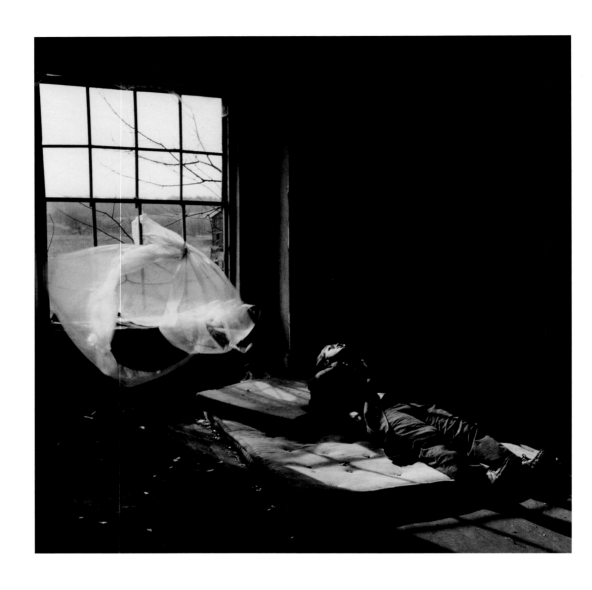

Plate 11 Robert C. May, *Chris Meatyard*, 1973. Gelatin silver print, 7 x 7 in. (17.8 x 17.8 cm). The Art Museum at the University of Kentucky, Lexington.

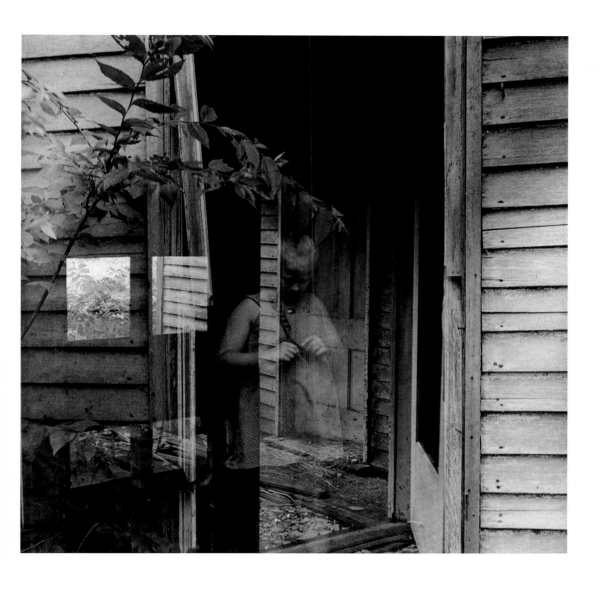

Plate 12 Robert C. May, *Melissa Meatyard*, late 1960s. Gelatin silver print, 5⅝ x 5¹³⁄₁₆ in. (14.3 x 14.8 cm). The Art Museum at the University of Kentucky, Lexington.

Plate 13 James Baker Hall, *Matthew*, ca. 1972. Gelatin silver print, 9¹³⁄₁₆ x 7³⁄₈ in. (24.9 x 18.8 cm). James Baker Hall Archive of Photographs and Films, Lexington.

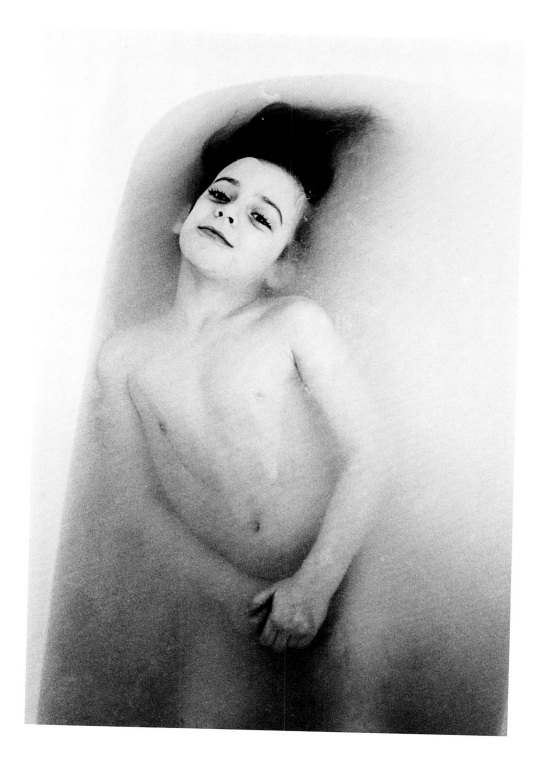

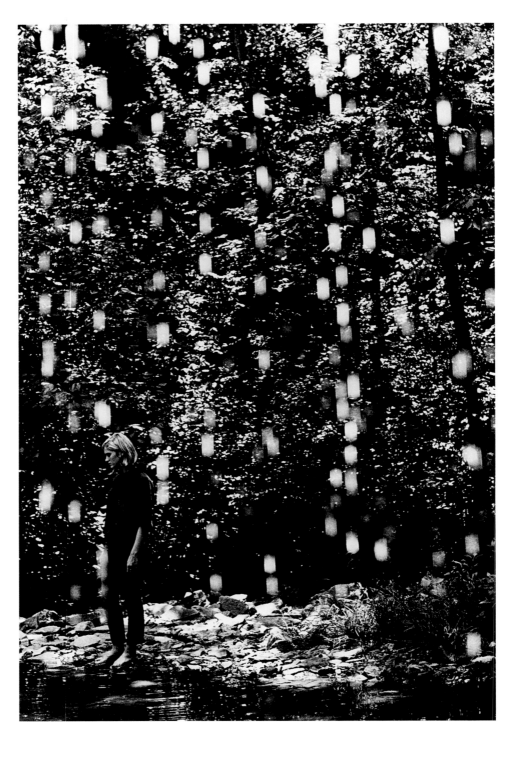

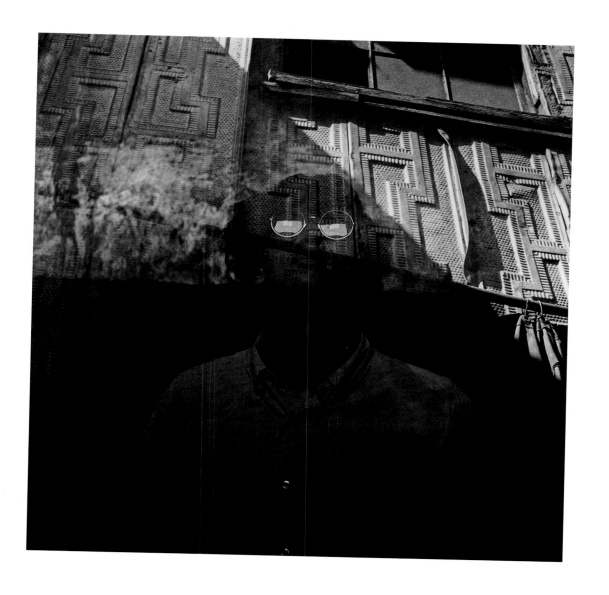

Opposite: Plate 14 Guy Mendes, *Juliette Lee Moore, Kit's Hole, Clark County, KY*, 1968. Gelatin silver print, 11⅞ x 7¾ in. (30.2 x 19.7 cm). Cincinnati Art Museum: FotoFocus Art Purchase Fund, 2016.8.

Plate 15 Robert C. May, *Untitled [Christopher Meatyard in front of wall]*, 1971. Gelatin silver print, 7 x 7 in. (17.8 x 17.8 cm). The Art Museum at the University of Kentucky, Lexington.

Opposite: Plate 16 Van Deren Coke, *Main Street Courthouse Entrance*, undated. Gelatin silver print, 12 x 9½ in. (30.4 x 24.1 cm). University of Kentucky Libraries Special Collections Research Center, Lexington.

Plate 17 Ralph Eugene Meatyard, *Untitled*, 1964. Gelatin silver print, 7¼ x 7⅜ in. (18.4 x 18.7 cm). Courtesy Fraenkel Gallery, San Francisco.

Plate 18 Jonathan Williams, *Ellsworth "Skip" Taylor*, undated. Color transparency. Yale Collection of American Literature, Beinecke Rare Book and Manuscript Library.

Plate 19 Jonathan Williams, *John Jacob Niles*, undated. Color transparency. Yale Collection of American Literature, Beinecke Rare Book and Manuscript Library.

Plate 21 Jonathan Williams, *Ronald Johnson*, undated. Color transparency. Yale Collection of American Literature, Beinecke Rare Book and Manuscript Library.

Plate 22 James Baker Hall, *Gene Meatyard*, ca. 1967. Gelatin silver print, 6½ x 7⅛ in. (16.5 x 18.1 cm). James Baker Hall Archive of Photographs and Films, Lexington.

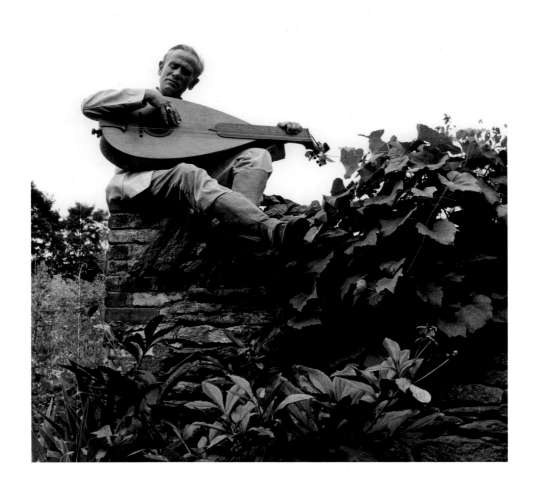

Plate 23 Van Deren Coke, *Untitled [John Jacob Niles playing a mandolin]*, undated. Gelatin silver print, 8⅜ x 7 in. (21.3 x 17.8 cm). The Art Museum at the University of Kentucky, Lexington.

Opposite: Plate 24 Cranston Ritchie, *Untitled*, ca. 1956–61. Gelatin silver print, 7¼ x 5⅝ in. (18.4 x 14.3 cm). University of Louisville Libraries Special Collections.

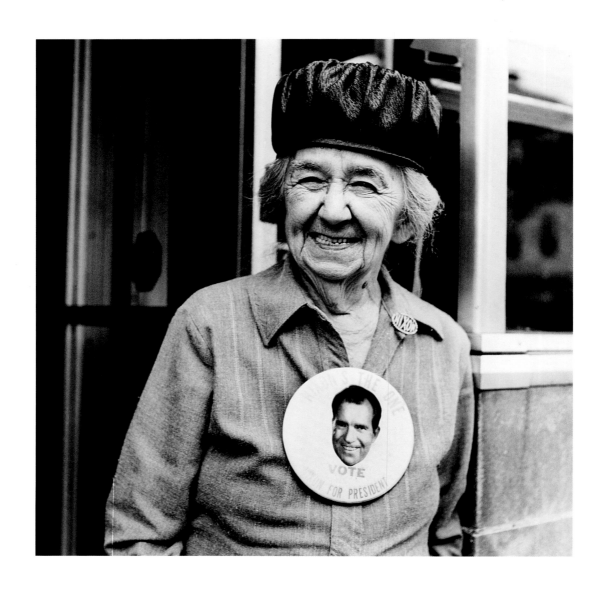

Plate 25 Guy Mendes, *Miss Hattie, Lexington, KY*, 1972. Gelatin silver print, 5¼ x 5¼ in. (13.3 x 13.3 cm). Courtesy of the artist.

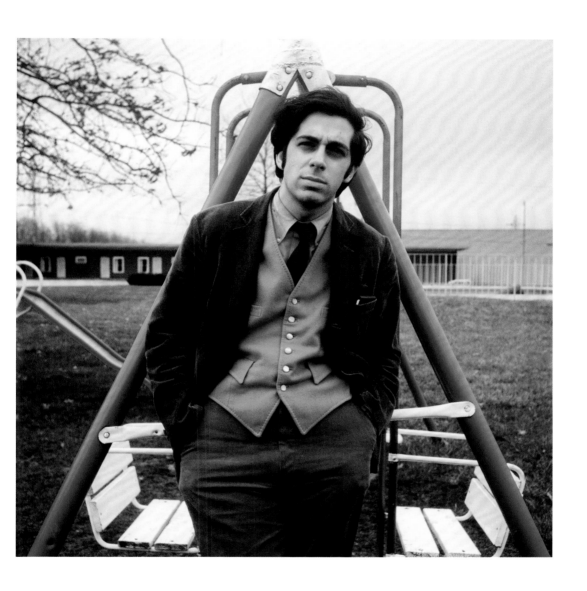

Plate 26 Jonathan Williams, *Jonathan Greene*, undated. Color transparency. Yale Collection of American Literature, Beinecke Rare Book and Manuscript Library.

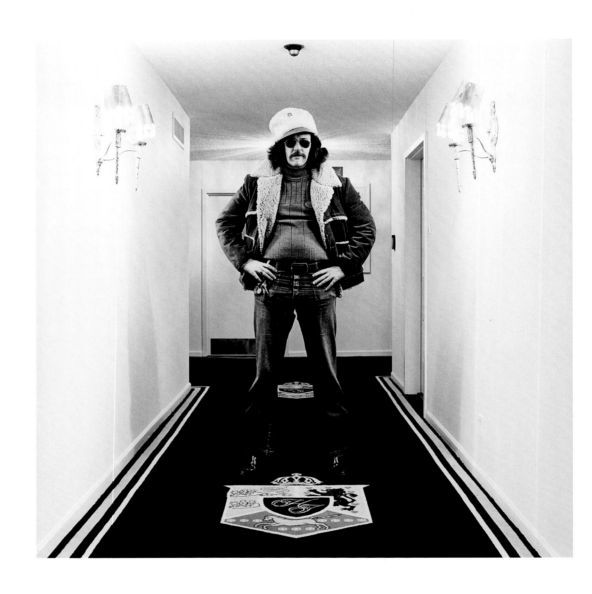

Plate 27 Guy Mendes, *Captain Kentucky, a.k.a. Ed McClanahan, Lexington, KY*, 1972.
Gelatin silver print, 15 x 15 in. (38.1 x 38.1 cm). Courtesy of the artist.

Plate 28 Ralph Eugene Meatyard, *Lucybelle Crater and Eastern man's friend Lucybelle Crater*, ca. 1970–72. Gelatin silver print, 7½ x 7½ in. (19.1 x 19.1 cm). Courtesy Fraenkel Gallery, San Francisco.

Place

Plate 29 Cranston Ritchie, *Untitled [Bottle]*, ca. 1956–61. Gelatin silver print, 8 x 7⅝ in. (20.3 x 19.4 cm). University of Louisville Libraries Special Collections.

Plate 30 Van Deren Coke, *Thou Shalt Not Steal*, 1963. Gelatin silver print, 6¹⁄₁₆ x 8¼ in. (15.4 x 21 cm). The Art Museum at the University of Kentucky, Lexington.

Plate 31 Charles Traub, *4th St., Louisville, Kentucky*, 1968. Gelatin silver print, 6 x 9¼ in. (15.2 x 23.5 cm). Courtesy of the artist.

Plate 32 Zygmunt S. Gierlach, *Sunday Morning*, undated. Gelatin silver print, 9¾ x 8 in. (24.7 x 20.3 cm). University of Kentucky Libraries Special Collections Research Center, Lexington.

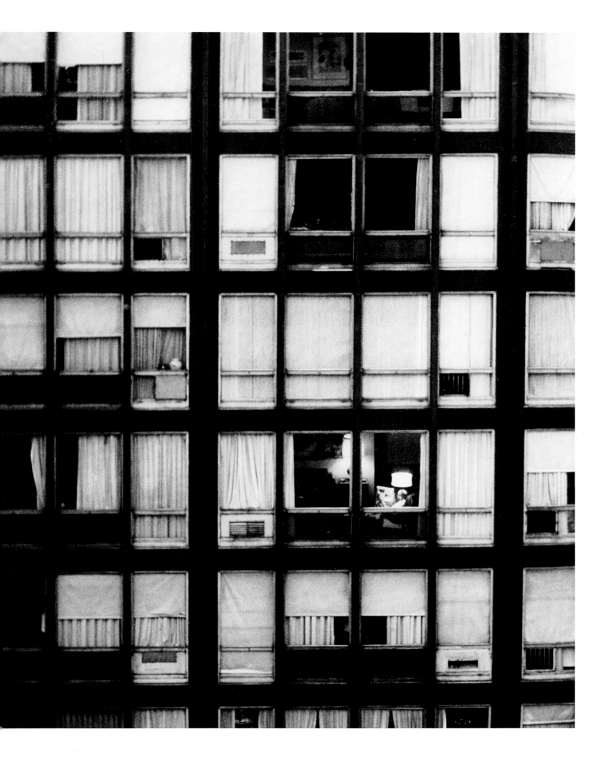

Plate 33 Cranston Ritchie, *Untitled [View down a Lexington street]*, ca. 1956–61. Gelatin silver print, 7½ x 7¼ in. (19.1 x 18.4 cm). University of Louisville Libraries Special Collections.

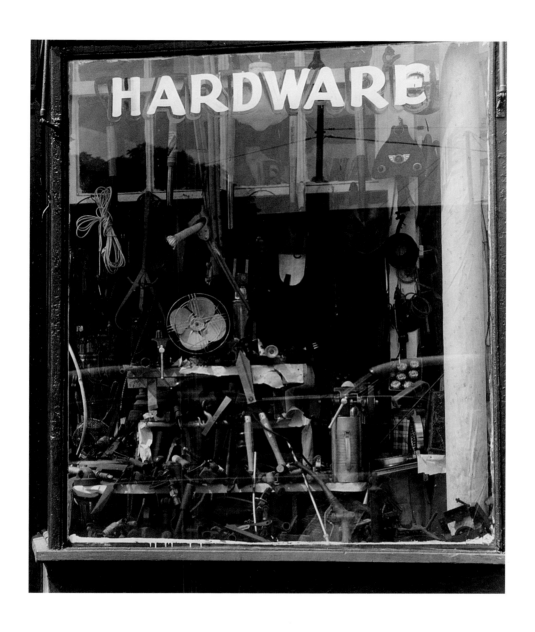

Plate 34 Ralph Eugene Meatyard, *Untitled*, 1959. Gelatin silver print, 7½ x 6¼ in. (19.1 x 15.8 cm). Courtesy Fraenkel Gallery, San Francisco.

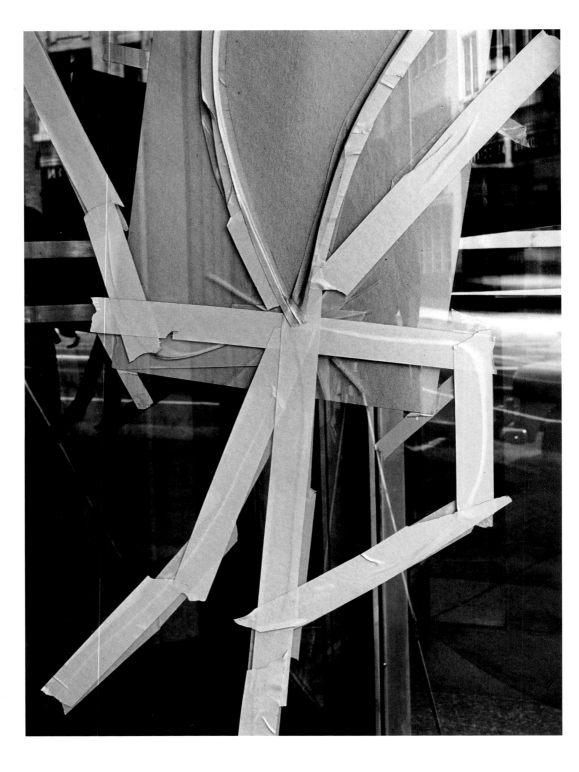

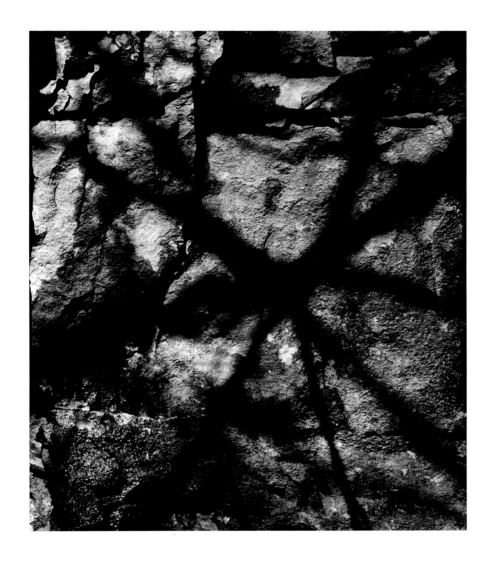

Opposite: Plate 35 Cranston Ritchie, *Untitled [Cracked window covered by tape]*, ca. 1956–61. Gelatin silver print, 9½ x 7 in. (24.1 x 17.8 cm). University of Louisville Libraries Special Collections.

Plate 36 Cranston Ritchie, *Untitled [Shadows on rock]*, 1958. Gelatin silver print, 7½ x 6½ in. (19.1 x 16.5 cm). University of Louisville Libraries Special Collections.

Plate 37 Ralph Eugene Meatyard, *Untitled*, 1955–56. Gelatin silver print, 9 x 9½ in. (22.9 x 24.1 cm). Courtesy Fraenkel Gallery, San Francisco.

Following pages: Plate 38 Van Deren Coke, *Davis Bottom*, undated. Gelatin silver print, 9 x 12½ in. (22.8 x 31.7 cm). University of Kentucky Libraries Special Collections Research Center, Lexington.

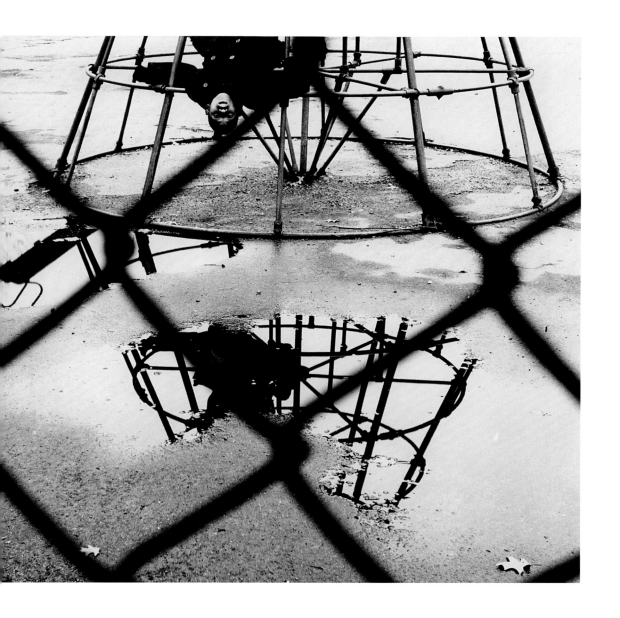

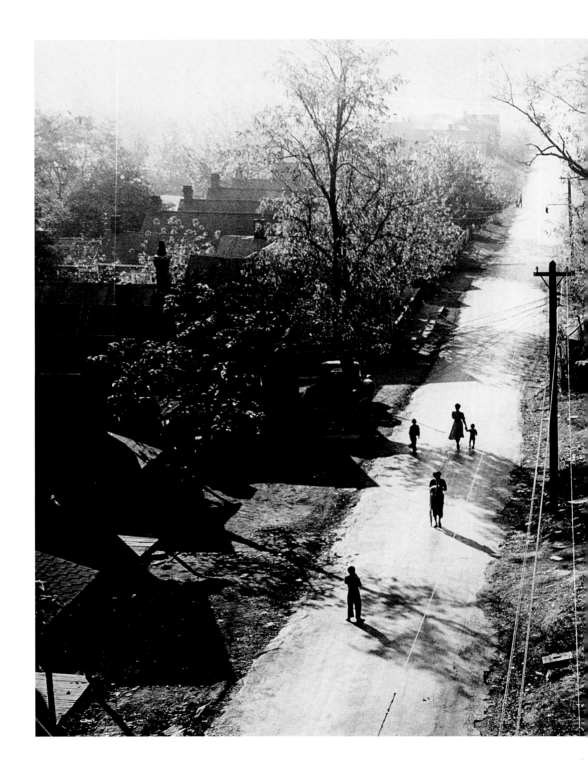

Plate 39 James Baker Hall, *Untitled*, ca. 1973. Gelatin silver print, 6¹¹⁄₁₆ x 6¹¹⁄₁₆ in. (17 x 17 cm). James Baker Hall Archive of Photographs and Films, Lexington.

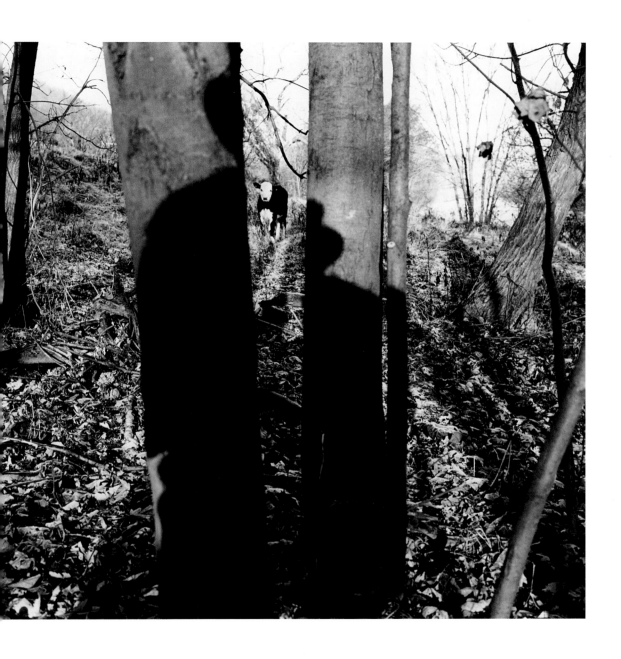

Plate 40 James Baker Hall, *Untitled*, ca. 1973. Gelatin silver print, 6¹¹⁄₁₆ x 6¹¹⁄₁₆ in. (17 x 17 cm).
Cincinnati Art Museum: FotoFocus Art Purchase Fund, 2016.29.

Plate 41 Robert C. May, *Untitled [Baskets of flowers]*, 1965. Gelatin silver print, 7⁵⁄₁₆ x 7¹¹⁄₁₆ in. (18.6 x 19.5 cm). The Art Museum at the University of Kentucky, Lexington.

Plate 42 Charles Traub, *Chicago*, 1969. Gelatin silver print, 6 x 6 in. (15.2 x 15.2 cm).
Courtesy of the artist.

Opposite: Plate 43 Ralph Eugene Meatyard, *Untitled*, ca. 1955. Gelatin silver print, 13½ x 10½ in. (34.3 x 26.7 cm). Courtesy Fraenkel Gallery, San Francisco.

Plate 44 Guy Mendes, *Tobacco Hanging, Nonesuch Church, Woodford County, KY*, 1975. Gelatin silver print, 9⅜ x 11⅝ in. (23.8 x 29.5 cm). Cincinnati Art Museum: FotoFocus Art Purchase Fund, 2016.10.

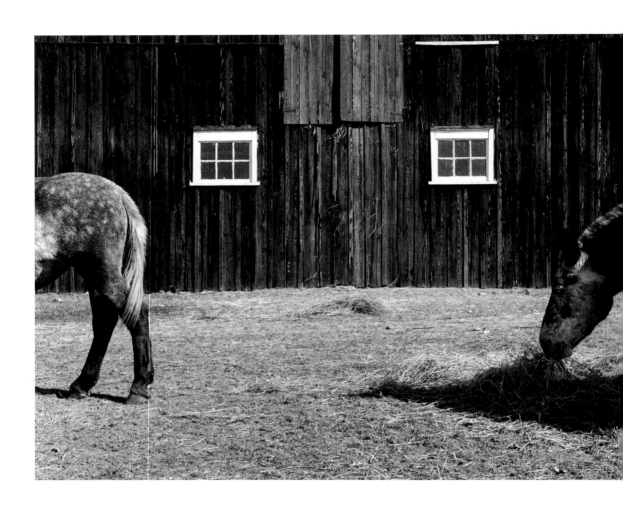

Plate 45 Van Deren Coke, *Untitled [Two horses]*, undated. Gelatin silver print, 10½ x 13½ in. (26.7 x 34.3 cm). The Art Museum at the University of Kentucky, Lexington.

Plate 46 James Baker Hall, *Barn*, ca. 1973. Gelatin silver print, 5¹³⁄₁₆ x 6 in. (14.8 x 15.2 cm).
James Baker Hall Archive of Photographs and Films, Lexington.

Plate 47 Cranston Ritchie, *Untitled [Rock formation]*, 1959. Gelatin silver print, 7 x 7½ in.
(17.8 x 19.1 cm). University of Louisville Libraries Special Collections.

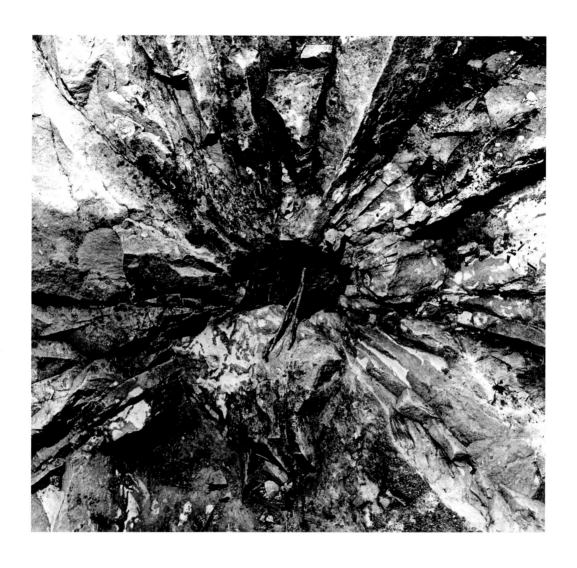

Plate 48 Cranston Ritchie, *Untitled [Rock]*, ca. 1956–61. Gelatin silver print, 7½ x 7¼ in.
(19.1 x 18.4 cm). University of Louisville Libraries Special Collections.

Plate 49 Thomas Merton, *Untitled*, ca. mid-1960s. Archival inkjet print from original negative, 6 1/16 x 9 in. (15.4 x 22.9 cm). The Thomas Merton Center at Bellarmine University, Louisville.

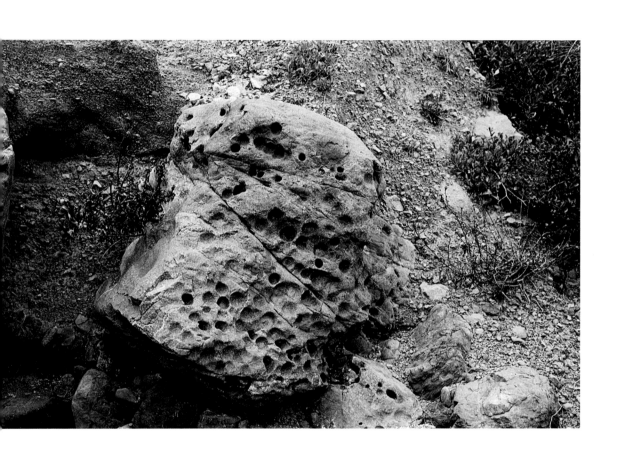

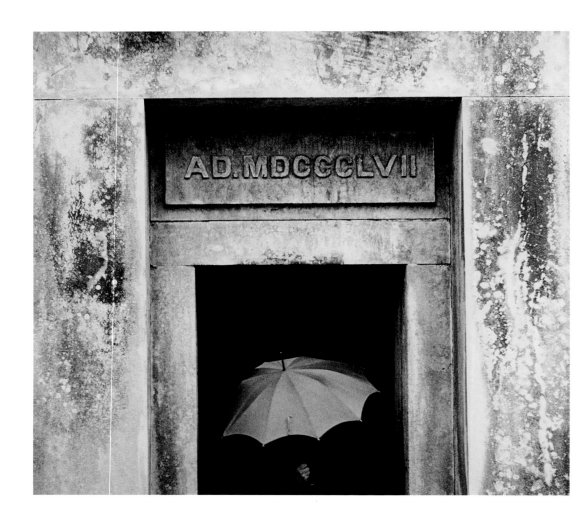

Plate 50 Van Deren Coke, *AD MDCCCLVII (from memento mori)*, 1955. Gelatin silver print, 7¾ x 8³⁄₁₆ in. (19.7 x 20.8 cm). The Art Museum at the University of Kentucky, Lexington.

Plate 51 Cranston Ritchie, *Untitled [Three tombstones]*, ca. 1956–61. Gelatin silver print, 7½ x 9½ in. (19.1 x 24.1 cm). University of Louisville Libraries Special Collections.

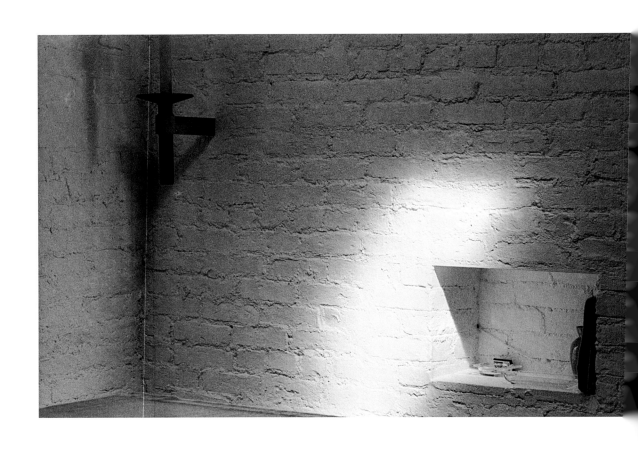

Plate 52 Thomas Merton, *Untitled*, ca. mid-1960s. Archival inkjet print from original negative, 6 x 9 in. (15.2 x 22.9 cm). The Thomas Merton Center at Bellarmine University, Louisville.

Plate 53 Thomas Merton, *Della Robbia, Alcove Shrine, Gethsemani*, ca. mid-1960s. Archival inkjet print from original negative, 6 x 9 in. (15.2 x 22.9 cm). The Thomas Merton Center at Bellarmine University, Louisville.

Plate 54 Cranston Ritchie, *Untitled ["BA" and leaf]*, ca. 1956–61. Gelatin silver print, 8 x 7⅝ in. (20.3 x 19.4 cm). University of Louisville Libraries Special Collections.

Plate 55 Guy Mendes, *Chard, Woodford County, KY*, 1975. Gelatin silver print, 8⁵⁄₁₆ x 8⁵⁄₁₆ in. (21.1 x 21.1 cm). Courtesy of the artist.

Plate 56 Guy Mendes, *Madison Place Porch, Lexington, KY*, 1974. Gelatin silver print, 9½ x 9½ in. (24.1 x 24.1 cm). Cincinnati Art Museum: FotoFocus Art Purchase Fund, 2016.9.

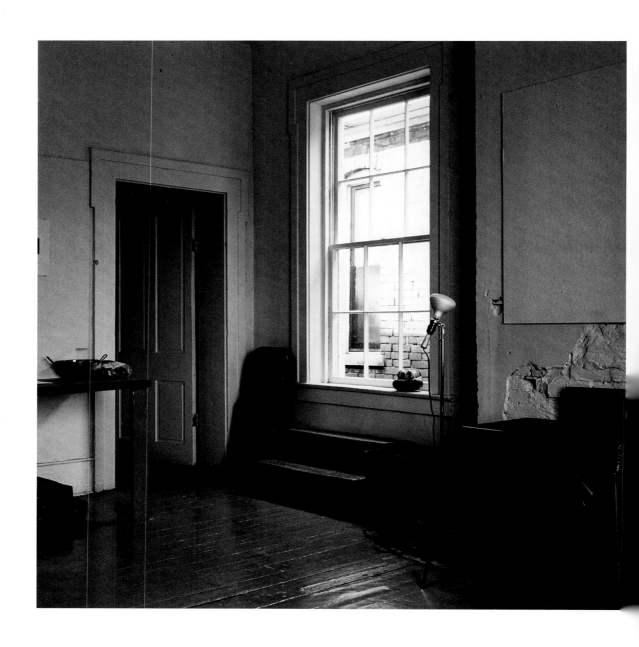

Plate 57 James Baker Hall, *Studio*, ca. 1969. Gelatin silver print, 6¹¹⁄₁₆ x 6¹¹⁄₁₆ in. (17 x 17 cm). James Baker Hall Archive of Photographs and Films, Lexington.

Plate 58 Robert C. May, *Untitled [Room in abandoned building]*, 1968. Gelatin silver print, 7⁵⁄₁₆ x 7¹¹⁄₁₆ in. (18.6 x 19.5 cm). The Art Museum at the University of Kentucky, Lexington.

Plate 59 Cranston Ritchie, *Ground Ties*, ca. 1956–61. Gelatin silver print, 9 x 7¼ in. (22.9 x 18.4 cm). University of Louisville Libraries Special Collections.

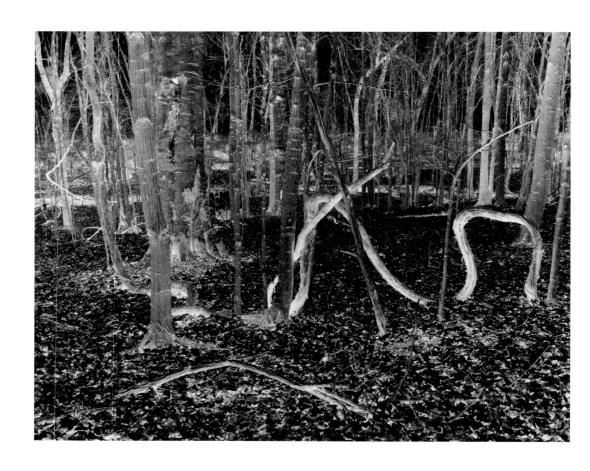

Plate 60 Charles Traub, *Oldhem County, Kentucky*, 1970. Gelatin silver print, 9 x 11 in. (22.9 x 28 cm). Courtesy of the artist.

Plate 61 Charles Traub, *Oldhem County, Kentucky*, 1970. Gelatin silver print, 9 x 11 in. (22.9 x 28 cm). Courtesy of the artist.

Plate 62 Thomas Merton, *Untitled*, ca. mid-1960s. Archival inkjet print from original negative, 6 x 9 in. (15.2 x 22.9 cm). The Thomas Merton Center at Bellarmine University, Louisville.

Plate 63 Thomas Merton, *Untitled*, ca. mid-1960s. Archival inkjet print from original negative, 7¼ x 9 in. (18.4 x 22.9 cm). The Thomas Merton Center at Bellarmine University, Louisville.

Plate 64 Ralph Eugene Meatyard, *Untitled*, 1964. Gelatin silver print, 6¼ x 7⅜ in. (15.9 x 18.7 cm). Courtesy Fraenkel Gallery, San Francisco.

Opposite: Plate 65 Cranston Ritchie, *Untitled [Vine on wire]*, ca. 1956–61. Gelatin silver print, 9½ x 7⅝ in. (24.1 x 19.4 cm). University of Louisville Libraries Special Collections.

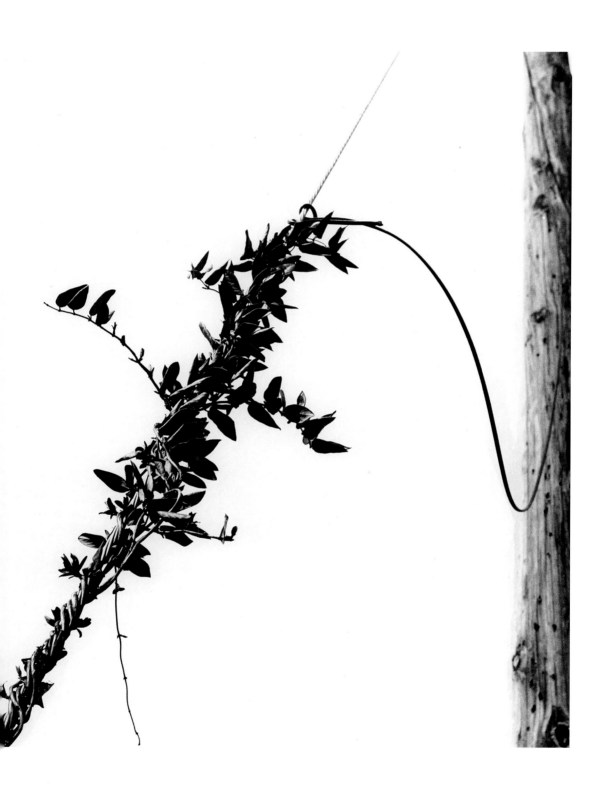

Plate 66 James Baker Hall, *Storrs*, 1973. Gelatin silver print, 6½ x 6⁷⁄₁₆ in. (16.5 x 16.4 cm). James Baker Hall Archive of Photographs and Films, Lexington.

Plate 67 Van Deren Coke, *Beginning of Northern Belt Line—Fall*, undated. Gelatin silver print, 7¼ x 9 in. (18.4 x 22.8 cm). University of Kentucky Libraries Special Collections Research Center, Lexington.

Following pages: Plate 68 Van Deren Coke, *Joyland Park Wildcat Ride*, undated. Gelatin silver print, 8¾ x 13 in. (22.2 x 33 cm). University of Kentucky Libraries Special Collections Research Center, Lexington.

Plate 69 Ralph Eugene Meatyard, *Untitled*, 1967–71. Gelatin silver print, 6¾ x 6¾ in. (17.1 x 17.1 cm). Courtesy Fraenkel Gallery, San Francisco.

Plate 70 Ralph Eugene Meatyard, *Untitled*, 1967–71. Gelatin silver print, 6¾ x 6¾ in. (17.1 x 17.1 cm). Courtesy Fraenkel Gallery, San Francisco.

Plate 71 Ralph Eugene Meatyard, *Untitled*, 1967–71. Gelatin silver print, 6¾ x 6¾ in. (17.1 x 17.1 cm). Courtesy Fraenkel Gallery, San Francisco.

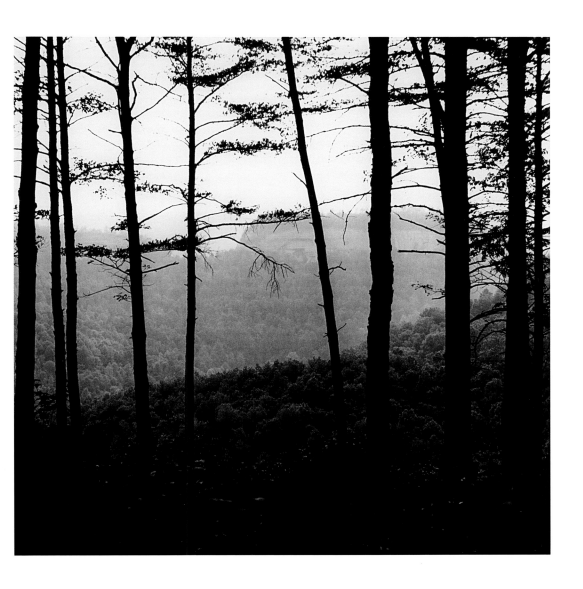

Plate 72 Ralph Eugene Meatyard, *Untitled*, 1967–71. Gelatin silver print, 6¾ x 6¾ in.
(17.1 x 17.1 cm). Courtesy Fraenkel Gallery, San Francisco.

Plate 73 Guy Mendes, *Marble Creek in Winter, Jessamine County, KY*, 1975.
Gelatin silver print, 12⅛ x 7⅞ in. (30.8 x 20 cm). Courtesy of the artist.

124

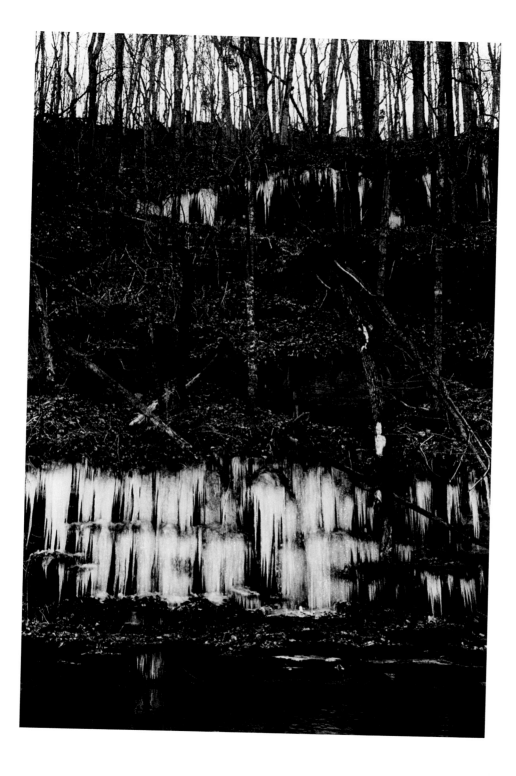

Plate 74 Charles Traub, *Fall*, 1968. Gelatin silver print, 6 x 6 in. (15.2 x 15.2 cm).
Courtesy of the artist.

Plate 75 Ralph Eugene Meatyard, *Untitled*, 1965. Gelatin silver print, 6¼ x 6¼ in. (15.9 x 15.9 cm). Courtesy Fraenkel Gallery, San Francisco.

Plate 76 Cranston Ritchie, *Untitled*, ca. 1956–61. Gelatin silver print, 8½ x 6⅞ in. (21.6 x 17.5 cm). Private collection.

Plate 77 Charles Traub, *Kentucky*, 1969. Gelatin silver print, 9 x 11 in. (22.9 x 28 cm).
Courtesy of the artist.

Plate 78 James Baker Hall, *Untitled*, ca. 1973. Gelatin silver print, 6⁵⁄₁₆ x 6³⁄₁₆ in. (16 x 15.7 cm). James Baker Hall Archive of Photographs and Films, Lexington.

Plate 79 Robert C. May, *Untitled [Barn and tall grass]*, 1970. Gelatin silver print, 6¹⁄₁₆ x 6¹⁄₁₆ in. (15.4 x 15.4 cm). The Art Museum at the University of Kentucky, Lexington.

Plate 80 Charles Traub, *Louisville, Kentucky*, 1969. Gelatin silver print, 6 x 6 in. (15.2 x 15.2 cm). Courtesy of the artist.

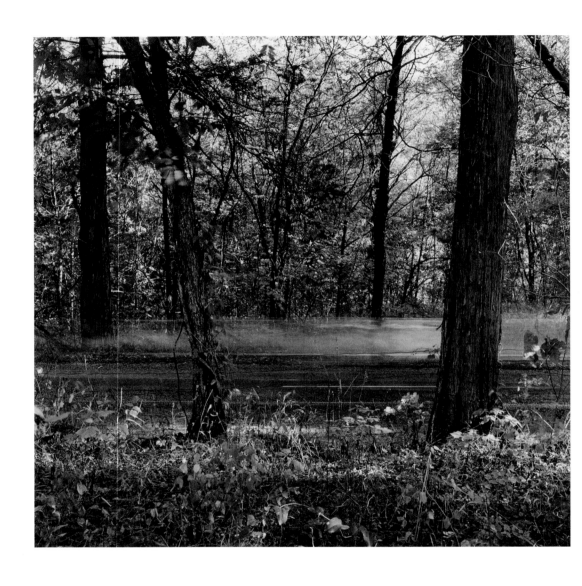

Plate 81 Robert C. May, *Untitled [Four trees in forest]*, undated. Gelatin silver print, 8⁷⁄₁₆ x 8½ in. (21.4 x 21.6 cm). The Art Museum at the University of Kentucky, Lexington.

Plate 82 Van Deren Coke, *Zero Point from Measuring Distance from Lexington*, undated. Gelatin silver print, 7½ x 9¼ in. (19 x 23.4 cm). University of Kentucky Libraries Special Collections Research Center, Lexington.

Experimentation

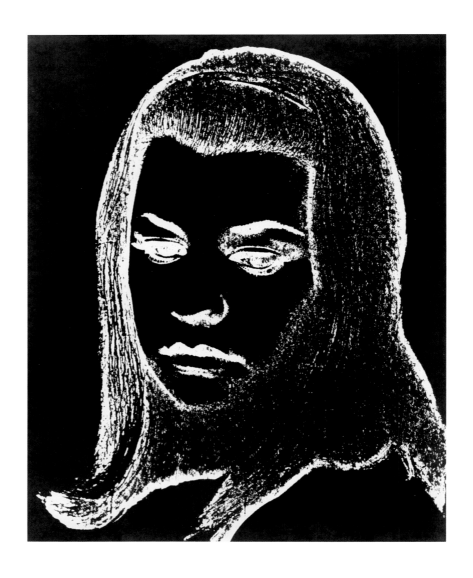

Plate 83 Zygmunt S. Gierlach, *Reverse Image*, undated. Gelatin silver print, 9¼ x 7½ in. (23.4 x 19 cm). University of Kentucky Libraries Special Collections Research Center, Lexington.

Opposite: Plate 84 Cranston Ritchie, *Untitled [Two mirrors]*, ca. 1956–61. Gelatin silver print, 9½ x 7½ in. (24.1 x 19.1 cm). University of Louisville Libraries Special Collections.

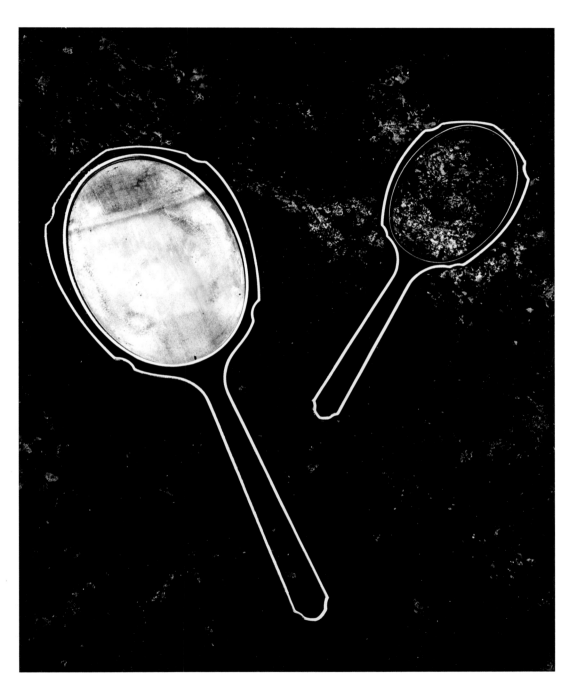

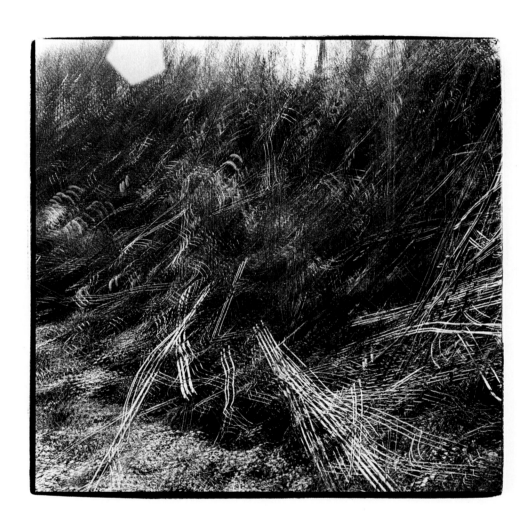

Plate 85 James Baker Hall, *Grasses*, ca. 1973. Gelatin silver print, 5¹³⁄₁₆ x 5¹³⁄₁₆ in. (14.8 x 14.8 cm). James Baker Hall Archive of Photographs and Films, Lexington.

Plate 86 Ralph Eugene Meatyard, *Untitled*, 1967. Gelatin silver print, 6¾ x 7⅛ in. (17.1 x 18.1 cm). Courtesy Fraenkel Gallery, San Francisco.

Plate 87 Robert C. May, *Untitled [Flowering bush with grave marker]*, 1974. Gelatin silver print, 9⁵⁄₁₆ x 9⁵⁄₁₆ in. (23.7 x 23.7 cm). The Art Museum at the University of Kentucky, Lexington.

Plate 88 Robert C. May, *Untitled [Headstone in field]*, 1976. Gelatin silver print, 7⁹⁄₁₆ x 7½ in. (19.2 x 19.1 cm). The Art Museum at the University of Kentucky, Lexington.

Plate 89 James Baker Hall, *Chairs*, ca. 1973. Gelatin silver print, 6¾ x 6½ in. (17.2 x 16.5 cm). Cincinnati Art Museum: FotoFocus Art Purchase Fund, 2016.28.

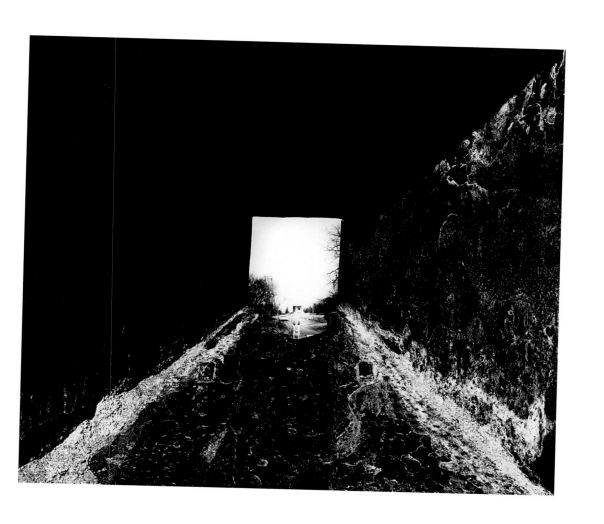

Plate 90 Cranston Ritchie, *Untitled*, ca. 1956–61. Gelatin silver print, 7 x 8 in. (17.8 x 20.3 cm). Cincinnati Art Museum: FotoFocus Art Purchase Fund, 2016.30.

145

Plate 91 Thomas Merton, *Untitled*, ca. mid-1960s. Archival inkjet print from original negative, 6⅛ x 9 in. (15.6 x 22.9 cm). The Thomas Merton Center at Bellarmine University, Louisville.

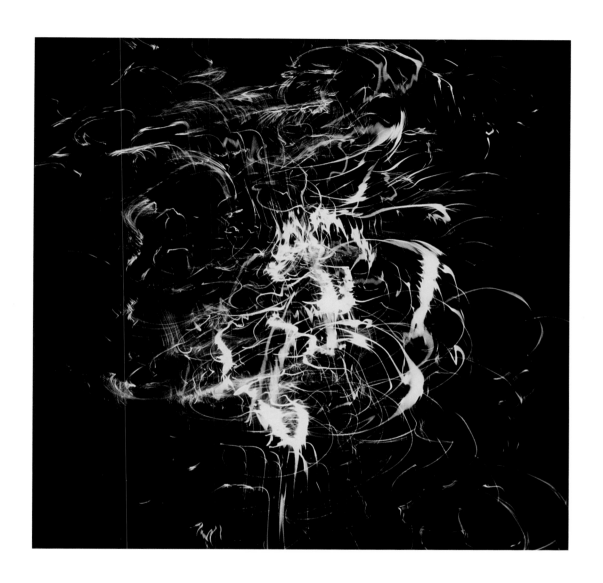

Plate 92 Ralph Eugene Meatyard, *Untitled*, 1959. Gelatin silver print, 7⅜ x 7½ in. (18.7 x 19.1 cm). Courtesy Fraenkel Gallery, San Francisco.

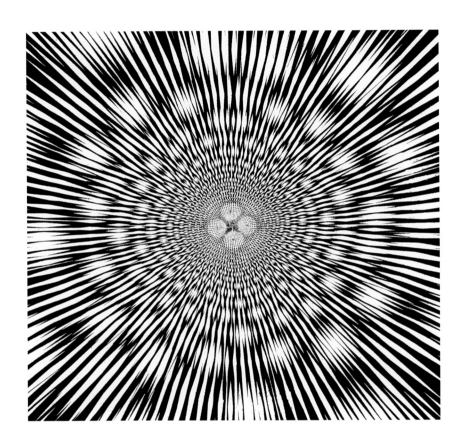

Plate 93 Zygmunt S. Gierlach, *Abstract*, ca. 1966. Gelatin silver print, 6¾ x 7 in. (17.1 x 17.7 cm). University of Kentucky Libraries Special Collections Research Center, Lexington.

Plate 94 Zygmunt S. Gierlach, *Abstract*, undated. Gelatin silver print, 8¾ x 13 in. (22.2 x 33 cm). University of Kentucky Libraries Special Collections Research Center, Lexington.

Plate 95 Robert C. May, *Untitled [Agriculture Extension, University of Kentucky]*, 1955.
Gelatin silver print, 10⁹⁄₁₆ x 13½ in. (26.8 x 34.3 cm). The Art Museum at the University
of Kentucky, Lexington.

Plate 96 Zygmunt S. Gierlach, *Untitled*, undated. Gelatin silver print, 10 x 8 in. (24.5 x 20.3 cm). University of Kentucky Special Collections Libraries Research Center, Lexington.

Plate 97 Zygmunt S. Gierlach, *Peafowl*, undated. Gelatin silver print, 9½ x 7⅝ in. (24.1 x 19.3 cm). University of Kentucky Libraries Special Collections Research Center, Lexington.

Plate 98 Thomas Merton, *Untitled Calligraphy*, ca. 1960s. Ink on paper, 13 x 12 in. (33 x 30.5 cm). The Thomas Merton Center at Bellarmine University, Louisville.

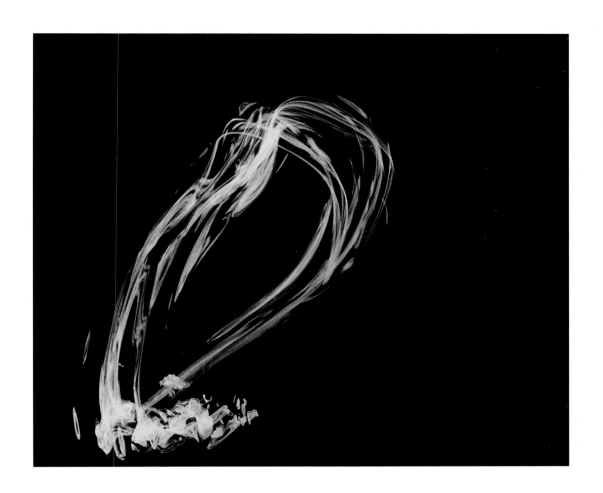

Plate 99 Ralph Eugene Meatyard, *Untitled*, 1959. Gelatin silver print, 5 x 6 in. (12.7 x 15.2 cm). Courtesy Fraenkel Gallery, San Francisco.

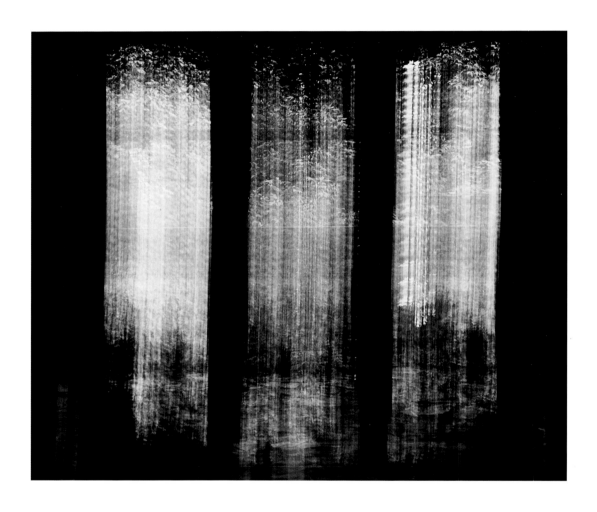

Plate 100 Cranston Ritchie, *Untitled*, ca. 1956–61. Gelatin silver print, 7½ x 8½ in. (19.1 x 21.6 cm). Cincinnati Art Museum: FotoFocus Art Purchase Fund, 2016.31.

Opposite: Plate 101 Zygmunt S. Gierlach, *Window Drapes*, ca. 1968. Gelatin silver print, 12¾ x 9 in. (32.3 x 22.8 cm). University of Kentucky Libraries Special Collections Research Center, Lexington.

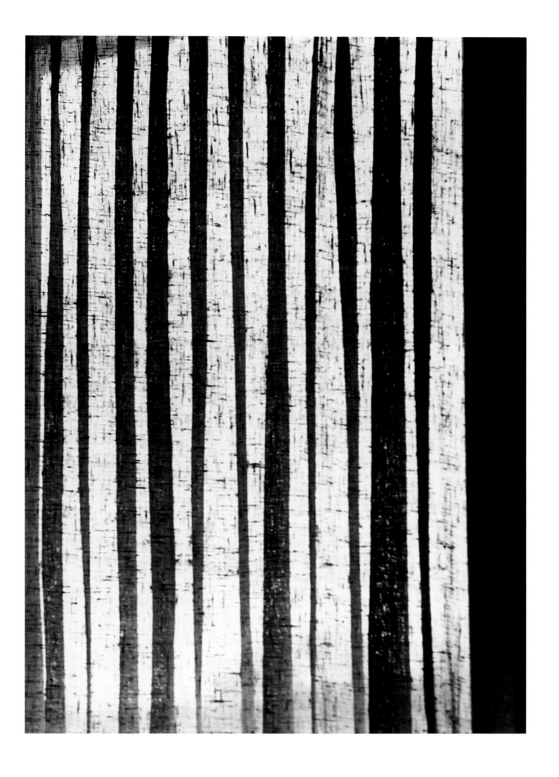

Plate 102 Zygmunt S. Gierlach, *Abstract*, undated. Gelatin silver print, 9⅞ x 7⅞ in. (25 x 20 cm). University of Kentucky Libraries Special Collections Research Center, Lexington.

Plate 103 Ralph Eugene Meatyard, *Untitled*, 1959. Gelatin silver print, 6½ x 8 in. (16.5 x 20.3 cm).
Courtesy Fraenkel Gallery, San Francisco.

Opposite: Plate 104 Ralph Eugene Meatyard, *Untitled*, 1959. Gelatin silver print, 6⅛ x 4⅝ in. (15.6 x 11.7 cm). Courtesy Fraenkel Gallery, San Francisco.

Plate 105 Ralph Eugene Meatyard, *Untitled*, 1959. Gelatin silver print, 6¼ x 5⅞ in. (15.9 x 14.9 cm). Courtesy Fraenkel Gallery, San Francisco.

Plate 106 Ralph Eugene Meatyard, *Untitled*, 1957–58. Gelatin silver print, 4¾ x 6⅝ in. (12.1 x 16.8 cm). Courtesy Fraenkel Gallery, San Francisco.

Plate 107 Charles Traub, *Mary, Chicago*, 1969. Gelatin silver print, 6 x 6 in. (15.2 x 15.2 cm). Courtesy of the artist.

Opposite: Plate 108 Thomas Merton, *Untitled Calligraphy*, ca. 1960s. Ink on paper, 14 x 9½ in. (35.6 x 24.1 cm). The Thomas Merton Center at Bellarmine University, Louisville.

Plate 109 Guy Mendes, *On Transylvania Park, Lexington, KY*, 1970. Gelatin silver print, 6¼ x 8⅞ in. (15.9 x 22.5 cm). Courtesy of the artist.

Opposite: Plate 110 Cranston Ritchie, *Untitled [Two twigs]*, ca. 1956–61. Gelatin silver print, 9 x 6½ in. (22.9 x 16.5 cm). University of Louisville Libraries Special Collections.

Chronology

Compiled by Emily Bauman and Brian Sholis

1936
December 3: The Lexington Camera Club holds its first meeting.

1937
Benjamin R. Hart joins the Lexington Camera Club, bringing an established connection to the world of art photography. Hart invites Ansel Adams, whom he knows personally, for a guest lecture.

1940
First formal public exhibition of the Lexington Camera Club, featuring 112 photographs by members, is held in room 205 of the Phoenix Hotel. Dr. Stanley Parks's *Spring Afternoon* wins first prize.
Van Deren Coke (1921–2004) has his first one-man show at the Art Gallery of the University of Kentucky.

1941
The Lexington Camera Club holds the *First Annual Kentucky Photographic Salon*, its second public exhibition.
December 10: Thomas Merton (1915–1968) enters the Abbey of Our Lady of Gethsemani.

1942
Van Deren Coke receives degrees in history and art history from the University of Kentucky.

1947
Cranston Ritchie (1923–1961) enrolls at the University of Kentucky.

1948
Thomas Merton's autobiography, *The Seven Storey Mountain*, is published.

1949
May 26: Thomas Merton is ordained as a priest at Gethsemani.
Merton's monograph *Seeds of Contemplation* and poetry collection *The Tears of the Blind Lions* are published.

1950

Ralph Eugene Meatyard (1925–1972) leaves his studies at Illinois Wesleyan University and moves to Lexington, Kentucky, to work for the large optical firm Tinder-Krauss-Tinder. He buys a Bolsey 35 mm camera to photograph his young son, Michael.

1951

Jonathan Williams (1929–2008) founds the Jargon Society after attending the Summer Institute at Black Mountain College. Photographer Harry Callahan had recommended Williams attend, and he studied photography while there.

Van Deren Coke founds, with his wife, the Creative Arts Gallery in Lexington. The gallery exhibits and sells paintings, sculptures, photographs, and crafts.

1952

Robert C. May (1935–1993) joins the Lexington Camera Club at age seventeen.

1954

Ralph Eugene Meatyard joins the Lexington Camera Club.

Focus on Lexington and Fayette County, Lexington Camera Club annual exhibition at the Art Gallery of the University of Kentucky. The catalogue cover image features Robert C. May's *Loom and Needle Garden Figure, Corner of Esplanade and East Short* (1954). Many of the photographs in the show are designed to bring attention to places and things in the region often seen but seldom really noticed.

1955

Van Deren Coke and Ralph Eugene Meatyard work together to photograph the African American neighborhood around Lexington's Georgetown Street. The photographic essay is exhibited the following year in a group show at A Photographer's Place, a gallery in New York City, and establishes Meatyard's career nationally.

Summer: Coke offers a series of photography classes at his home. Jim Bill Craig, Dr. Zygmunt S. Gierlach (1915–1989), Robert C. May, and Ralph Eugene Meatyard participate.

Coke's photographs are exhibited at the Allen R. Hite Institute of Art, University of Louisville.

1956

January 9–February 4: *Creative Photography 1956* exhibition at the Art Gallery of the University of Kentucky. The Lexington Camera Club sponsors the invitational exhibition, organized by Van Deren Coke and featuring the works of seventeen contemporary photographers. Prints from members of the club are also shown, and the recently deceased club member Dr. Charles Kavanaugh is featured. A forty-page catalogue is made for the exhibition.

Robert C. May receives a BA in history from the University of Kentucky. He begins work as a photographer for the agriculture information department at the University of Kentucky.

Summer: Coke and Meatyard attend a three-week photography seminar organized by Henry Holmes Smith at Indiana University. They meet Aaron Siskind and Minor White. White introduces Meatyard to Zen Buddhism.

Coke resigns as president of the Van Deren Hardware Company and enters Indiana University as a graduate student in art history and fine arts.

1957

James Baker Hall (1935–2009) graduates from the University of Kentucky with a BA in English. He would attend graduate school at Stanford and return to Kentucky as a visiting professor from 1968 to 1969.

1958

Ralph Eugene Meatyard and Van Deren Coke present a two-man show at Roy DeCarava's A Photographer's Gallery, New York.

Coke receives MA from Indiana University and enrolls in Harvard University's PhD program in art history.

1959

January 11: Opening of Lexington Camera Club 1959 invitational exhibition. Works by Dr. W. Brooks Hamilton, Dr. Noble T. Macfarlane, R. Eugene Meatyard, S. Stofer Ringo, Cranston N. Ritchie, Ben C. Turpin, and Drexel R. Wells are exhibited.

1960s

Radiology professor and practitioner Zygmunt S. Gierlach offers his professional offices at 1517 South Limestone as meeting and exhibition space for the Lexington Art League (LAL), which was founded in 1957. There is now a gallery named for him in LAL's Loudoun House. Camera Club members also show work in Gierlach's office gallery, including a November 1965 exhibition of Robert C. May's photographs.

1960

Ralph Eugene Meatyard meets poet, photographer, and publisher
 Jonathan Williams.

1961

Thomas Merton meets photographer John Howard Griffin after years of
 friendly correspondence.

December 26: Cranston Ritchie dies of cancer at age thirty-eight.

1962

Van Deren Coke is named chairman of the University of New Mexico's
 art department. He also serves as director of the University Art
 Museum from 1962 to 1966.

1963

Guy Davenport (1927–2005) and Wendell Berry begin teaching in the English
 department at the University of Kentucky during the fall semester.

The University of Kentucky awards Thomas Merton an honorary doctorate
 in literature.

1964

Guy Davenport and Ralph Eugene Meatyard meet and become friends.
 Jonathan Williams arranges the meeting, and brings Ronald Johnson,
 Stan Brakhage and his daughter Crystal, Bonnie Jean Cox, and
 Davenport to the Meatyards' home.

Wendell Berry's book of poetry *The Broken Ground* is published.

The Society for Photographic Education (SPE) incorporates its bylaws.
 The SPE emerges at a time when photography is increasingly included
 in college departments of art rather than journalism.

1965

Guy Davenport is in charge of inviting speakers in the arts and humanities
 for year-long program in celebration of the University of Kentucky's
 centennial. Guests include poets Louis Zukofsky and Hugh Kenner,
 novelist Eudora Welty, scientist and inventor Buckminster Fuller, and
 filmmaker Stan Brakhage.

Jonathan Greene founds Gnomon Press, which will publish works by authors
 including Wendell Berry and Jonathan Williams and by photographers
 including Guy Mendes (born 1948) and Ralph Eugene Meatyard.

Thomas Merton retreats to hermitage on the grounds of the Abbey of Our
 Lady of Gethsemani.

1966

Jonathan Greene moves to Lexington. Jonathan Williams introduces Greene
 to Ralph Eugene Meatyard. Meatyard introduces Greene to Robert C. May
 shortly thereafter. Guy Mendes arrives at the University of Kentucky,
 hoping to become a journalist.
Ralph Eugene Meatyard meets Wendell Berry and James Baker Hall.
Jargon Society publishes Guy Davenport's long poem *Flowers and Leaves*.
Davenport is named faculty adviser to the *Kentucky Review*, a new campus
 magazine of literature and the arts.

1967

January 17: Jonathan Williams, Guy Davenport, and Ralph Eugene Meatyard
 drive to the Abbey of Gethsemani, where Meatyard meets Thomas
 Merton. In the ensuing months, Meatyard takes more than one hundred
 photographs of Merton.
Photographs of Thomas Merton taken by Meatyard are exhibited at
 Bellarmine University.
Merton's collection of essays, *Mystics and Zen Masters*, is published. The
 essays address early monasticism, Russian Orthodox spirituality,
 the Shakers, and Zen Buddhism.

1968

Photography 1968 is presented at Transylvania University's Morlan Gallery.
 Ralph Eugene Meatyard has the idea for the show, which features a
 representative selection of prints from photographers at the George
 Eastman House of Photography, Indiana University, the University of
 New Mexico, and the Lexington Camera Club.
Publication of Wendell Berry's poetry book, *Openings*, with a jacket photo-
 graph by Meatyard.
December 10: Thomas Merton dies as the result of an electrocution accident
 in Bangkok.

1969

Concrete poet Emmett Williams is fall semester artist-in-residence at the
 University of Kentucky College of Fine Arts. He teaches painting
 at the university and exhibits twelve *Black Light Poems on Canvas*.
October 15: First issue of the *blue-tail fly*. Led and edited by Guy Mendes,
 the newspaper emerges as an alternative to the more traditional student
 newspaper, the *Kentucky Kernel*. Eleven issues are published between
 1969 and 1971. The not-for-profit paper has an activist slant, with

articles on racial equality and civil liberties, environmentalism, the legalization of marijuana, protests against the Vietnam War, and the ongoing struggle against eastern Kentucky strip mining. Contributors include Guy Mendes, Ed McClanahan, Wendell Berry, Jonathan Greene, and Ralph Eugene Meatyard.

1970

Jonathan Greene's Gnomon Press publishes *Ralph Eugene Meatyard*, a compilation of photographs by Meatyard with notes by Wendell Berry and Arnold Gassan.

Wendell Berry's book of poems *Farming: A Handbook* is published.

Meatyard organizes *Photography 1970*, inviting participation from Robert Heinecken at the University of California–Los Angeles, Harry Callahan at the Rhode Island School of Design, and Arnold Gassan at Ohio University, and their students.

July 1: Van Deren Coke is appointed deputy director of the Museum of Modern Art photography department.

1971

The Allen R. Hite Institute Gallery at the University of Louisville mounts an exhibition of Cranston Ritchie's photographs.

The Unforeseen Wilderness: Kentucky's Red River Gorge is published. The book features text by Wendell Berry and photographs by Ralph Eugene Meatyard. The area is threatened by the building of a dam on the Red River.

1972

Lexington Camera Club founder W. Brooks Hamilton retires from his position as professor of hygiene and public health at the University of Kentucky.

Ralph Eugene Meatyard organizes *Photography "72"* exhibition with the assistance of Robert C. May. The show is presented at the Speed Art Museum in Louisville. Jerry Crouch, Fred W. Steffen, Zygmunt S. Gierlach, and Ralph Eugene Meatyard compose the catalogue committee. The exhibition is third in a series looking at photography at art schools across the United States. *Photography "72"* includes works from the University of Illinois, the University of Louisville, the Massachusetts Institute of Technology, the University of Nebraska, and the Lexington Camera Club.

May 7: Ralph Eugene Meatyard dies of cancer in Lexington.

1973

The Lexington Camera Club is disbanded.

1974

Ralph Eugene Meatyard's *The Family Album of Lucybelle Crater* is published by Jargon Society.

Aperture Foundation publishes the monograph *Ralph Eugene Meatyard*, edited by James Baker Hall.

Guy Davenport's short story collection *Tatlin!* is published. Davenport claims he first saw Tatlin's name in a concrete poem by Jonathan Williams, "But Will It Fly?"

1976

Gnomon Press publishes Guy Mendes's *Local Light: Photographs Made in Kentucky.* The collection includes photographs by Meatyard, May, Mendes, Coke, and others.

1978

Gnomon Press publishes *I Shall Save One Land Unvisited: Eleven Southern Photographers*, selected by Jonathan Williams. The book accompanies a traveling exhibition and includes Meatyard, May, Mendes, and others.

1979

Van Deren Coke is appointed curator of photography at the San Francisco Museum of Modern Art. During his tenure, he establishes and directs the museum's department of photography. Coke remains connected to Kentucky through 1990, serving as juror for various competitions and awards and curating or co-organizing exhibitions.

1986

Gnomon Press publishes Guy Mendes's monograph *Light at Hand,* with a foreword by Ed McClanahan and an afterword by Jonathan Williams.

1989

Robert C. May organizes *The Lexington Camera Club, 1936–1972.* The exhibition takes place at the University of Kentucky Art Museum. The University of Kentucky publishes an accompanying catalogue.

Photography Credits